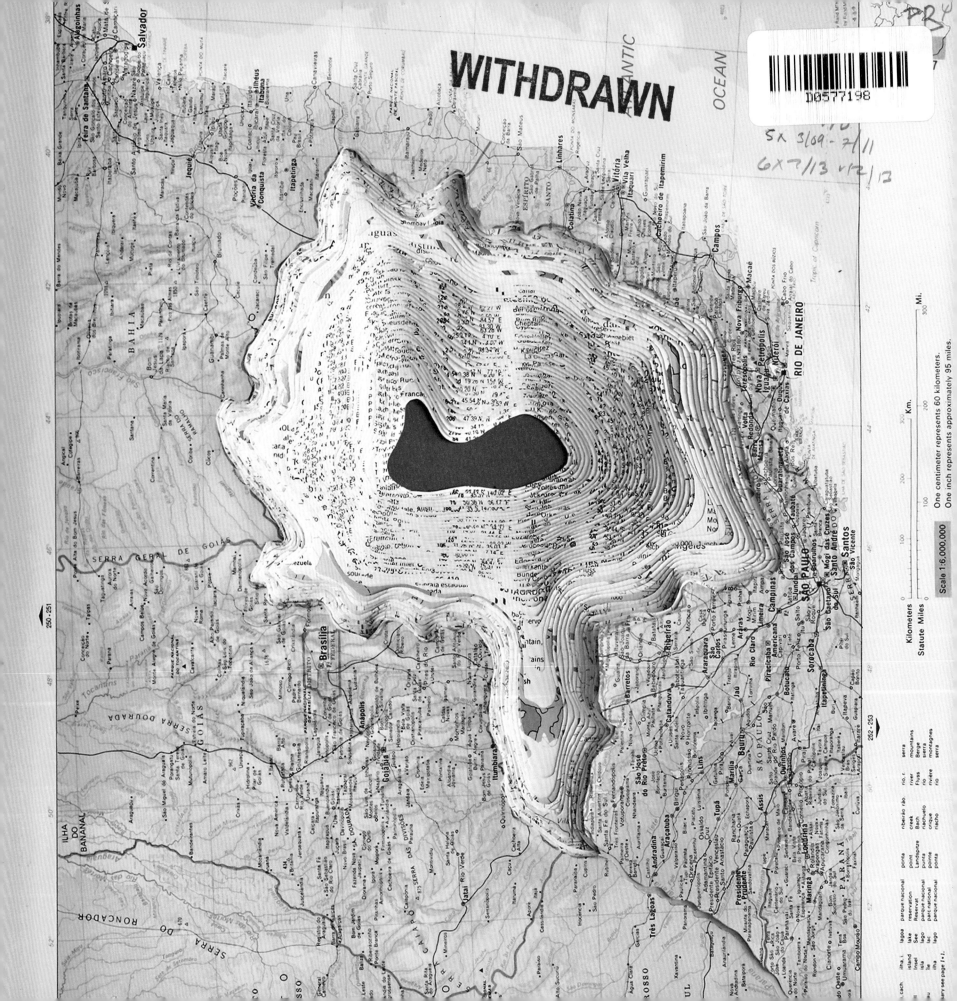

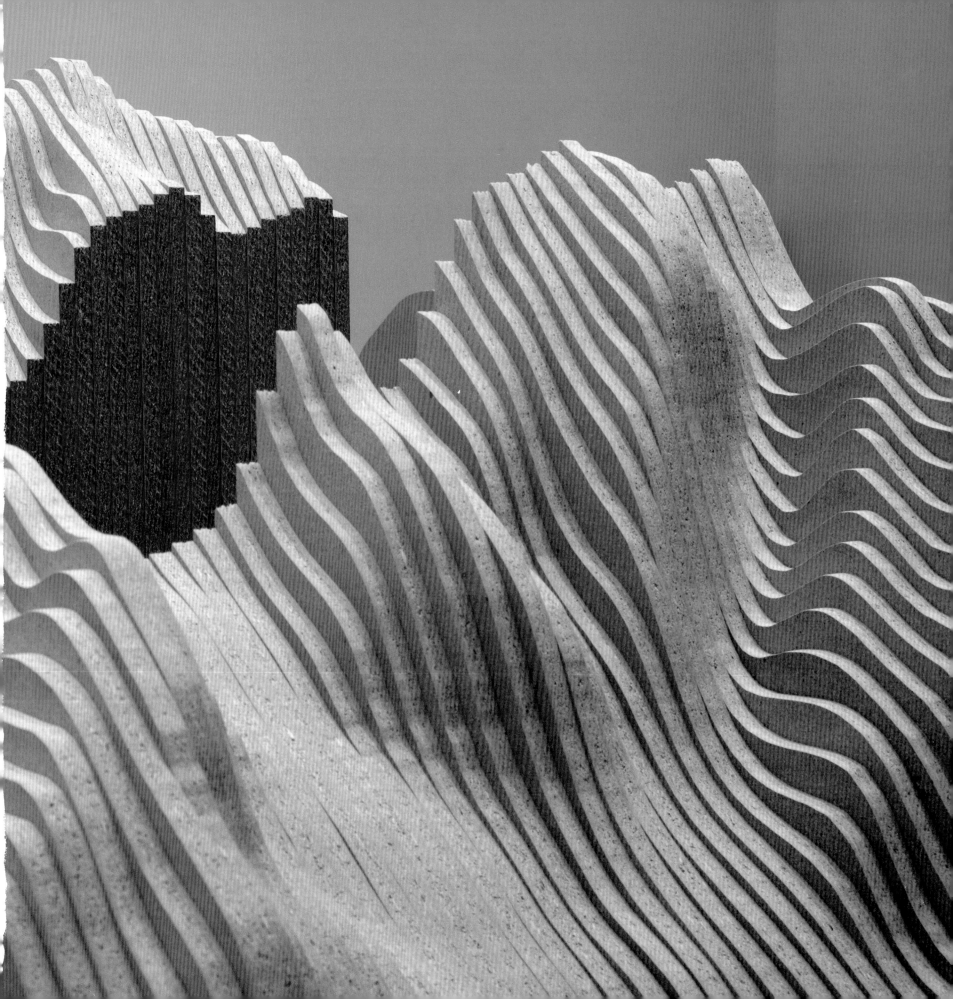

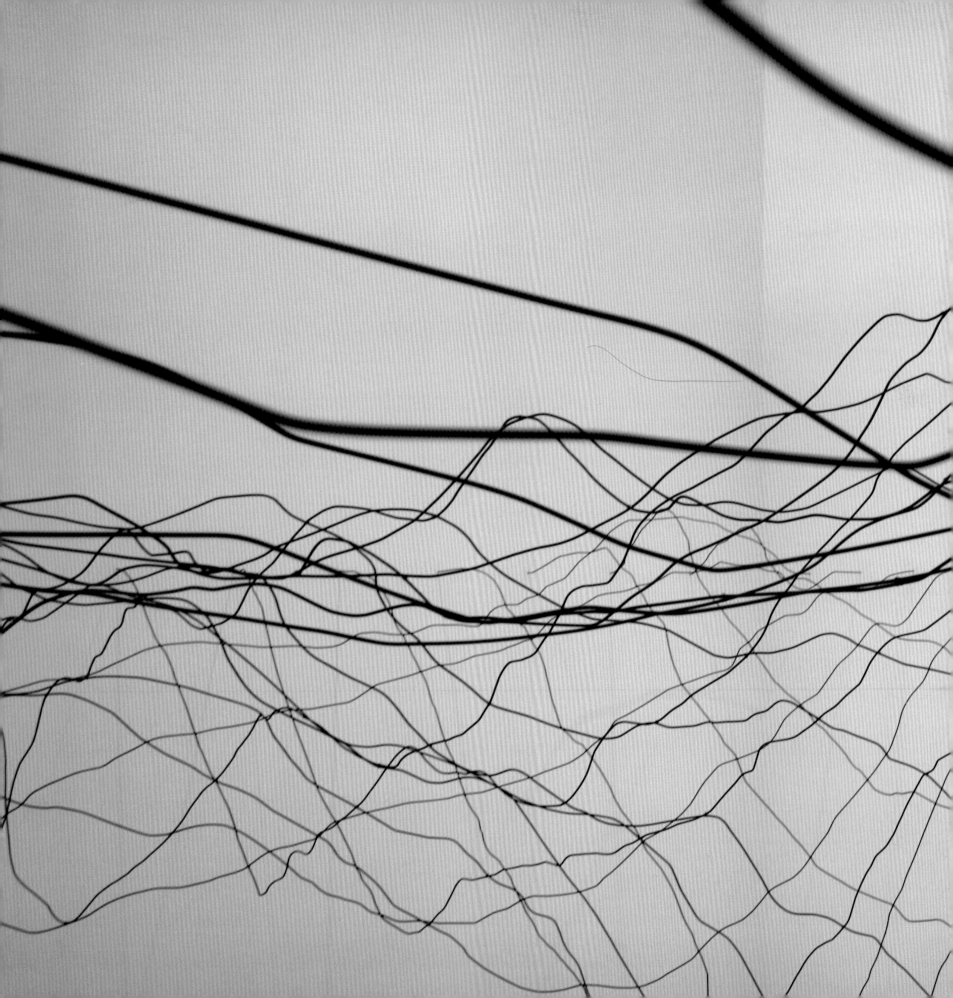

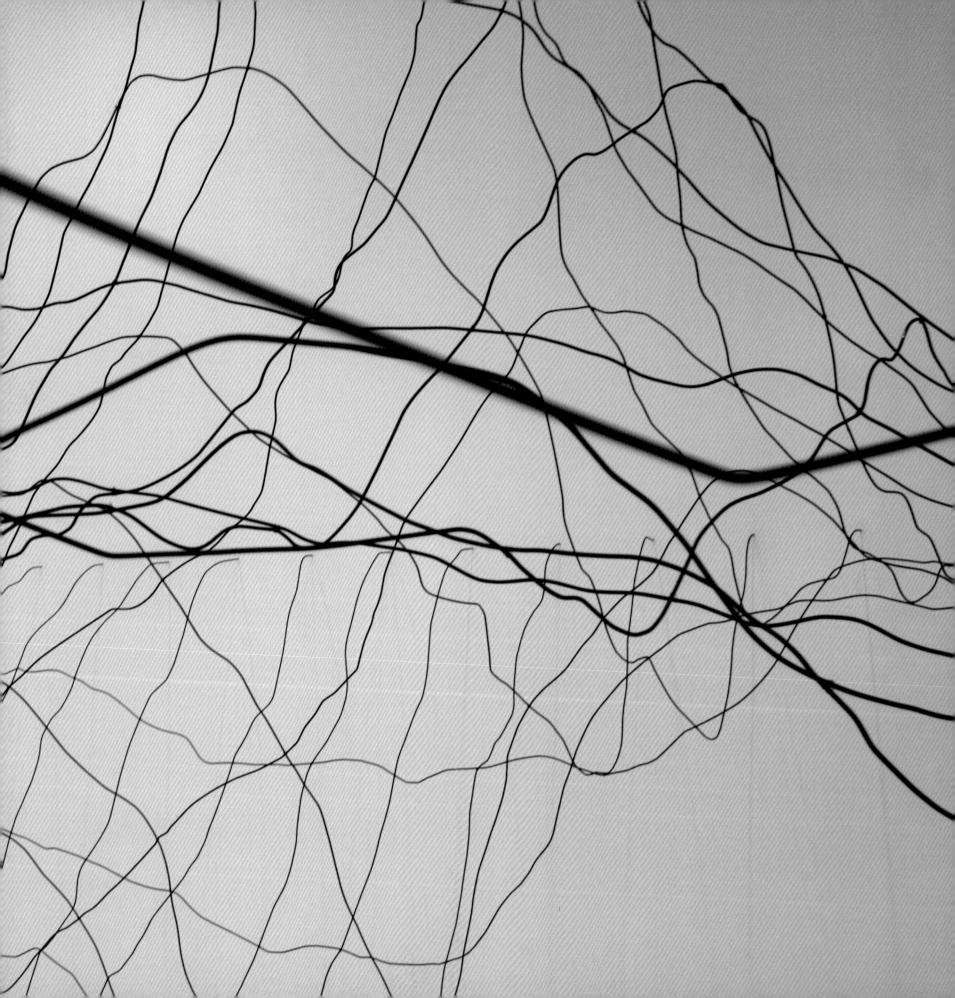

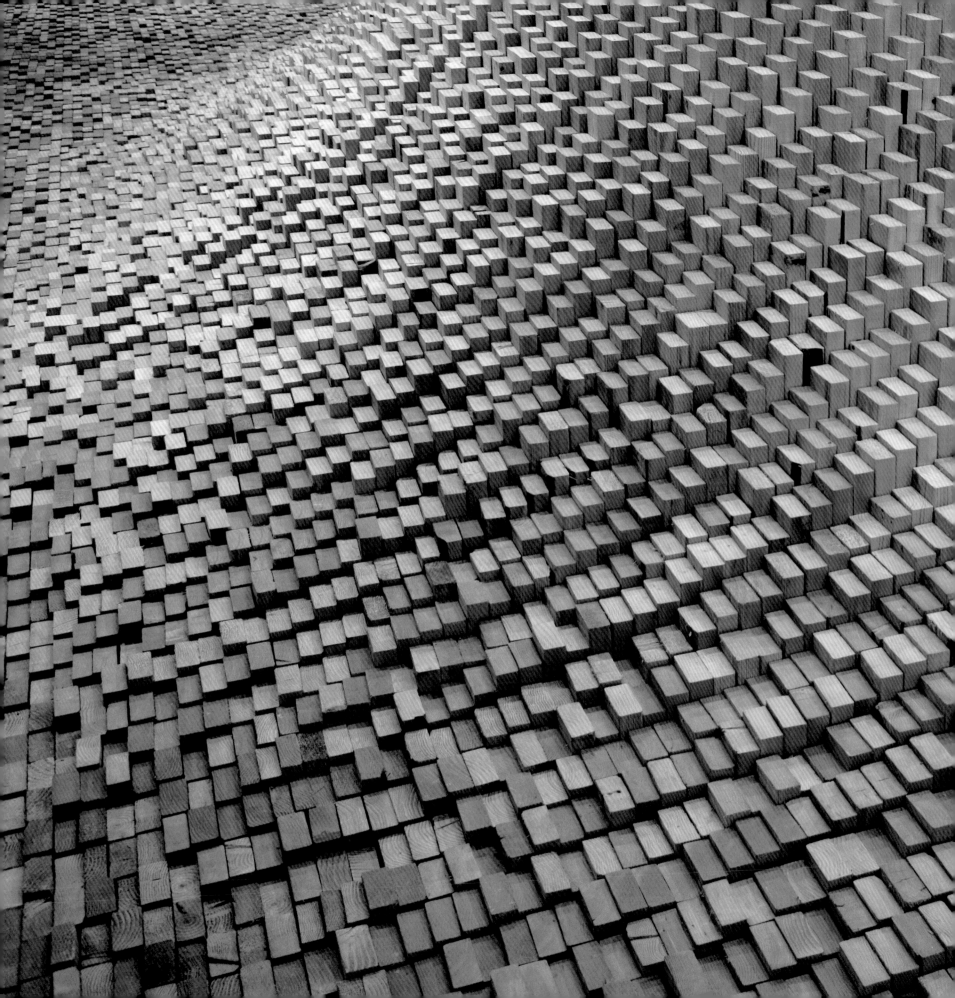

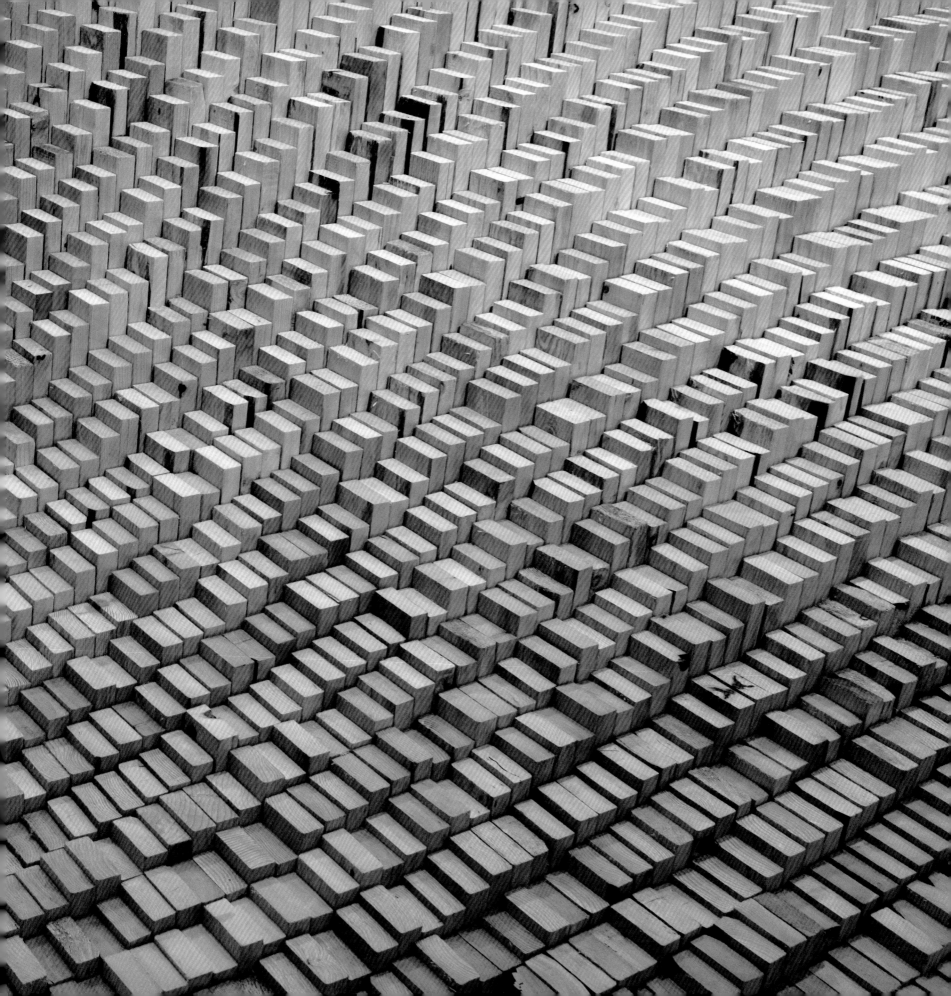

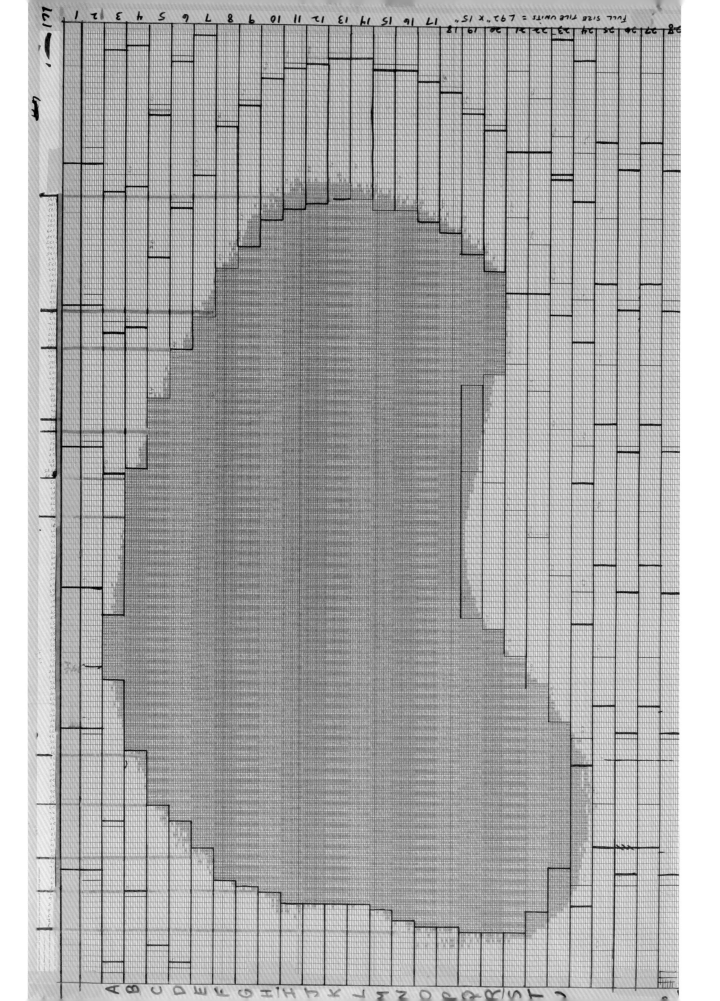
FULL SIZE TILE UNITS = 29½" X 15"

Essays by
Richard Andrews
John Beardsley

Foreword by
Lawrence Weschler

Maya Lin Systematic Landscapes

Henry Art Gallery
University of Washington
Seattle

Yale University Press
New Haven and London

This book is published in conjunction with the exhibition *Maya Lin: Systematic Landscapes,* presented at the Henry Art Gallery, University of Washington, Seattle, from April 22 to September 3, 2006.

Maya Lin: Systematic Landscapes is organized for the Henry Art Gallery by Richard Andrews, Director. Major support for this exhibition has been provided by the Paul G. Allen Family Foundation, ArtsFund, The Boeing Company, and PONCHO. Additional support was provided by The Peter Norton Family Foundation, Kongsgaard-Goldman Foundation, Haas Charitable Trusts, NBBJ Group, and the Washington State Arts Commission. In-kind support was provided by Simpson Timber Company–Northwest, Grand Hyatt Seattle, KrekowJenningsInc., and Vulcan Inc.

The Henry Art Gallery is very grateful for exhibition funding provided by William and Ruth True, Sharon and Greg Maffei, Cathy and Michael Casteel, Susan and Furman Moseley, Victoria N. Reed, Eleanor and Charles F. Pollnow, Jim and Laura Donald, Kim Lyford Bishop, Rebecca and Alexander Stewart, Fohs Foundation and Jerry Sohn, and donors to the Special Exhibition Initiative.

Library of Congress Cataloging-in-Publication Data
Lin, Maya Ying.
 Maya Lin : systematic landscapes / essays by Richard Andrews, John Beardsley ; foreword by Lawrence Weschler.
 p. cm.
 Issued in connection with an exhibition held Apr. 22–Sept. 3, 2006, Henry Art Gallery, Seattle.
 Includes bibliographical references.
 ISBN 10: 0-300-12120-2
 ISBN 13: 978-0-300-12120-9 (hardcover : alk. paper)
 1. Lin, Maya Ying—Exhibitions. 2. Nature (Aesthetics)—Exhibitions. I. Andrews, Richard, 1949–. II. Beardsley, John. III. Henry Art Gallery. IV. Title.
N6537.L54A4 2006
709'.2—dc22 2006018718

Published by the Henry Art Gallery in association with Yale University Press, New Haven and London
www.henryart.org
www.yalebooks.com

Edited by Carolyn Vaughan
Proofread by Jessica Eber
Designed by John Hubbard
Separations by iocolor, Seattle
Produced by Marquand Books, Inc., Seattle
 www.marquand.com
Printed in China by C&C Offset Printing Co., Ltd.

Acknowledgments for excerpts on pages 11–13:

Excerpt from *Sacred Hunger* by Barry Unsworth, W.W. Norton, 1992.

"The Precision, " © 1999 by Linda Gregg. Reprinted from *Things and Flesh* with the permission of Graywolf Press, Saint Paul, Minnesota.

Excerpt from *On Rigor in Science* by Jorge Luis Borges, Viking Penguin. Translated by Alastair Reid.

The passage about Nicolas of Cusa is adapted from the coda of Lawrence Weschler's *Everything That Rises: A Book of Convergences,* McSweeney's, 2006.

Contents

11 Foreword
Lawrence Weschler

61 Outside In:
Maya Lin's Systematic Landscapes
Richard Andrews

85 Hidden in Plain View:
The Land Art of Maya Lin
John Beardsley

104 Selected Works, Exhibitions,
and Bibliography

106 Checklist of the Exhibition

108 Henry Art Gallery Staff and
Board of Trustees

110 Acknowledgments

112 Illustrations and
Photography Credits

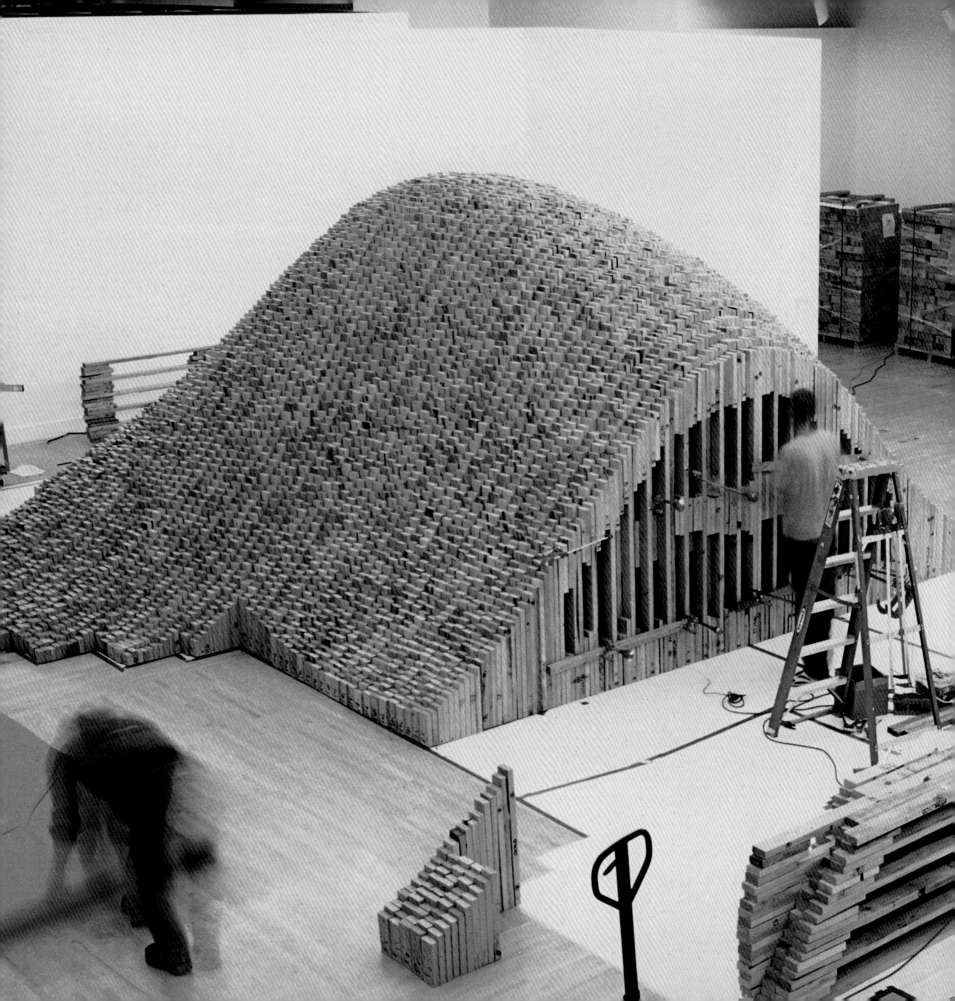

Foreword

Lawrence Weschler

I went to see Maya Lin's new show coming together at the Henry one morning recently on a visit to Seattle—actually, it was just beginning to come together, more apart really than anywhere near complete, though still, still you could get a sense of where things were tending—and as usual with Maya's brimmingly evocative work, I kept finding myself being put in mind: of this, and then that, and then of course right past all of that to the hushed core, the stilled center, into which one eventually always seems to find oneself arriving with her work.

But before the hush, for instance, being put in mind of this, from Barry Unsworth's novel *Sacred Hunger*, the description of the construction of a ship in drydock:

Work on the ship continued; she rose on her stocks from day to day, proceeding by ordained stages from notion to form. Like any work of the imagination, she had to maintain herself against disbelief, guard her purpose through metamorphoses that made her barely recognizable at times—indeed she had looked more herself in the early stages of the building, with the timbers of the keel laid in place and scarphed together to form her backbone and the stem and sternpost jointed to it. Then she had already the perfect dynamic of her shape, the perfect declaration of her purpose. But with the attachment of the vertical frames, which conform to the design of the hull and so define the shape of it, she looked a botched, dishevelled thing for a while, with the raw planks standing up loose all round her. Then slowly she was gripped into shape again, clamped together by the transverse beams running athwart her and the massive wales that girdled her fore and aft. She was riveted and fastened with oak trenails and wrought-iron bolts driven through the timbers and clenched. And so she began to look like herself again, as is the gradual way of art.

And then of this, Linda Gregg's
"The Precision" from her book
Things and Flesh:

There is a modesty in nature. In the small
of it and in the strongest. The leaf moves
just the amount the breeze indicates
and nothing more. In the power of lust, too,
there can be a quiet and clarity, a fusion
of exact moments. There is a silence of it
inside the thundering. And when the body swoons,
it is because the heart knows its truth.
There is directness and equipoise in the fervor,
just as the greatest turmoil has precision.
Like the discretion a tornado has when it tears
down building after building, house by house.
It is enough, Kafka said, that the arrow fit
exactly into the wound that it makes. I think
about my body in love as I look down on these
lavish apple trees and the workers moving
with skill from one to the next, singing.

And then, oddly, I'm really not quite sure why,
of this, from Borges (by way of Alastair Reid):

". . . In that Empire, the Art of Cartography had
achieved such Perfection that the map of a single
Province occupied a whole City, and the map of
the Empire, a whole Province. With time, these
disproportionate maps gave no satisfaction, and
the College of Cartographers conceived a map
of the Empire that had the same dimensions as
the Empire, and that coincided with it at every
point. Subsequent Generations, less concerned
with the study of Cartography, understood that
the extended Map was useless and with a certain
impiety abandoned it to the inclemencies of the
Sun and of Winters. In the deserts of the West,
certain tattered fragments of the Map are still
to be found, sheltering Animals and Beggars; in
the whole country, nothing else remains of the
Discipline of Geography."
(*On Rigor in Science;* Suarez Miranda, Larida 1685)

Before finally looping back to my old friend Nicolas of Cusa, to whom I always seem to be returning (though perhaps seldom more pertinently than here), Nicola Cusano, that late medieval Renaissance man (1401–1464), a devout church leader and mathematical mystic who was at the same time one of the founders of modern experimental science, advocate, among other things, of the notion that the earth, far from being the center of the universe, might itself be in motion around the sun (this a good two generations before Copernicus)—and yet, for all that, a cautionary skeptic as to the limits of that kind of quantifiable knowledge and thus, likewise, a critic of the then-reigning Aristotelian/Thomistic worldview. No, he would regularly insist, one could never achieve knowledge of God, or, for that matter, of the wholeness of existence, through the systematic accretion of more and more factual knowledge. Picture, he would suggest, an n-sided equilateral polygon nested inside a circle, and now keep adding to the number of its sides: triangle, square, pentagon, hexagon, and so forth. The more sides you add, the closer it might seem that you would be getting to the bounding circle—and yet, he insisted, in another sense, the farther away you would in fact be becoming. Because a million-sided regular polygon, say, has, *precisely*, a million sides and a million angles, whereas a circle has none, or maybe at most one. No matter how many sides you added to your polygon (ten million, a hundred million), if you were ever going to achieve any true sense of the whole, at some point you were going to have to make the leap from the chord to the arc, a leap of faith as it were, a leap which in turn can only be accomplished in or through grace, which is to say in some significant way *gratis*, for free—beyond, that is, the n-sided language of mere cause and effect.

With Maya's pieces, how one is always shifting back and forth like that, between the particulate and the seamless, between material facticity and transcendent form—all of that, all of that, all of that *stuff*, and then grace quite simply abounding.

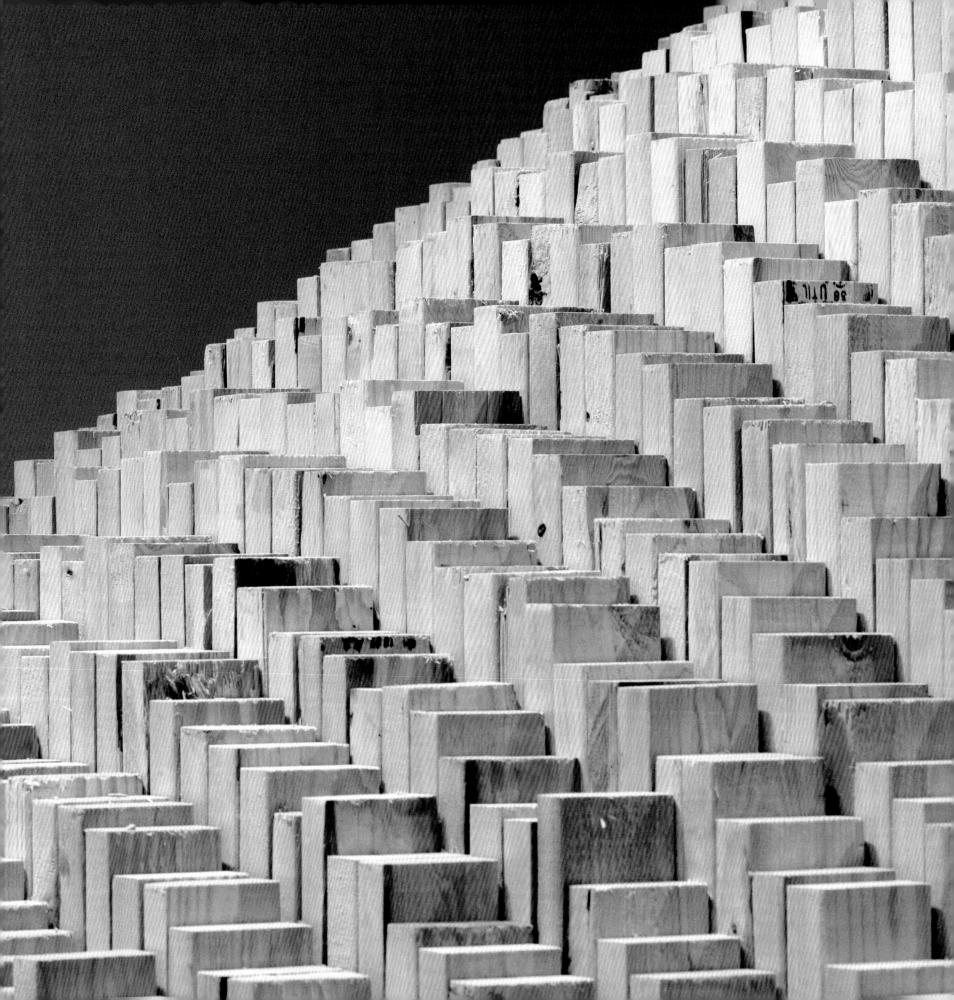

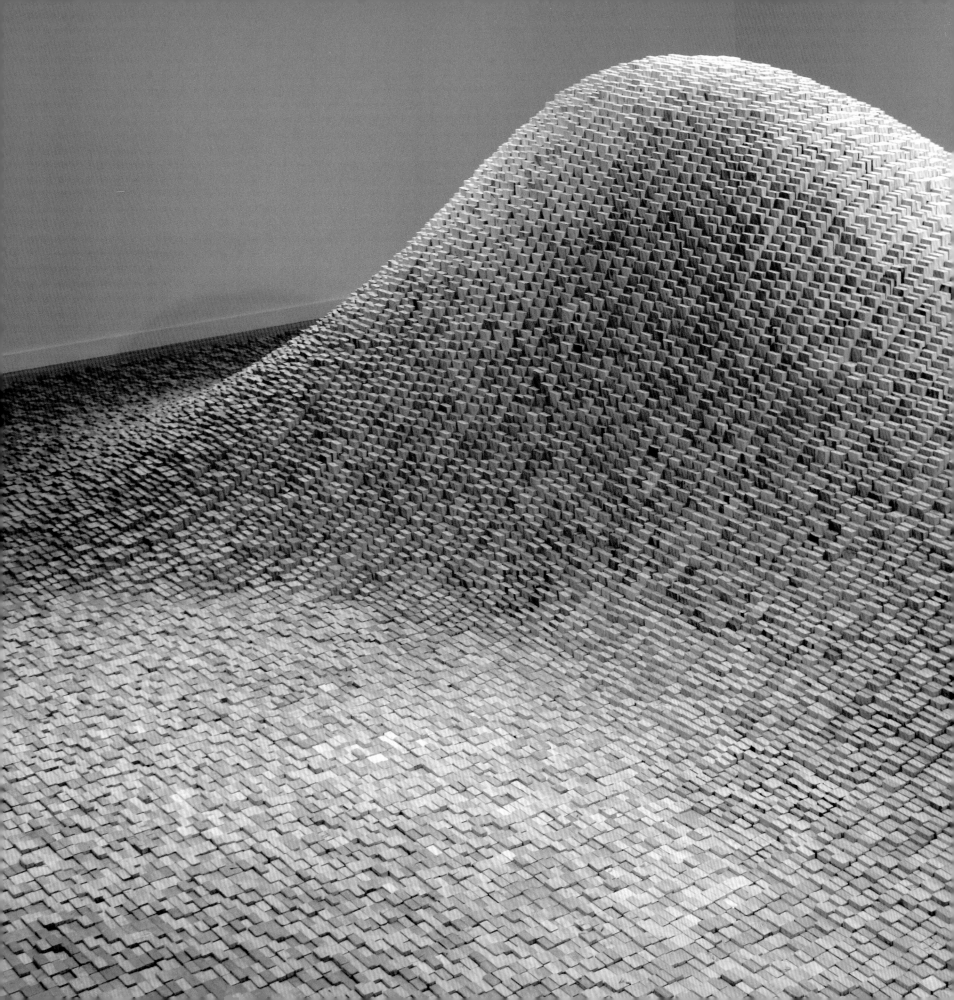

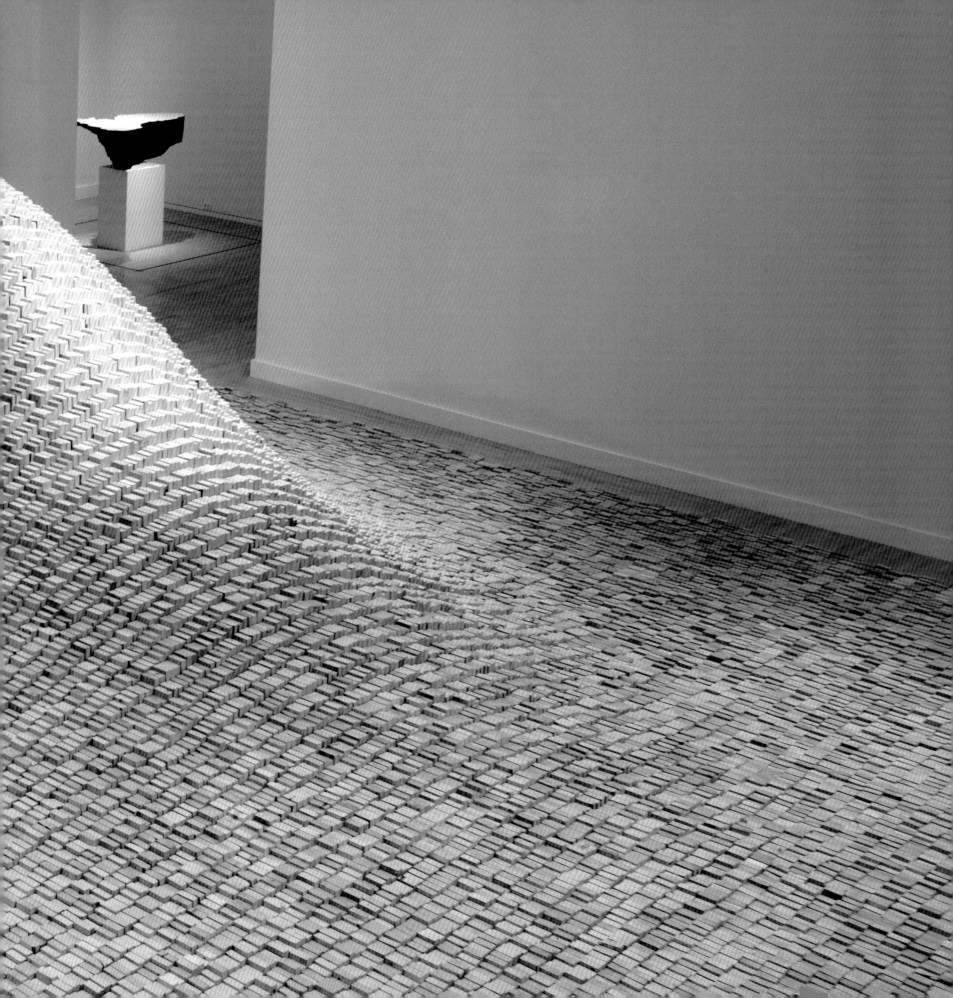

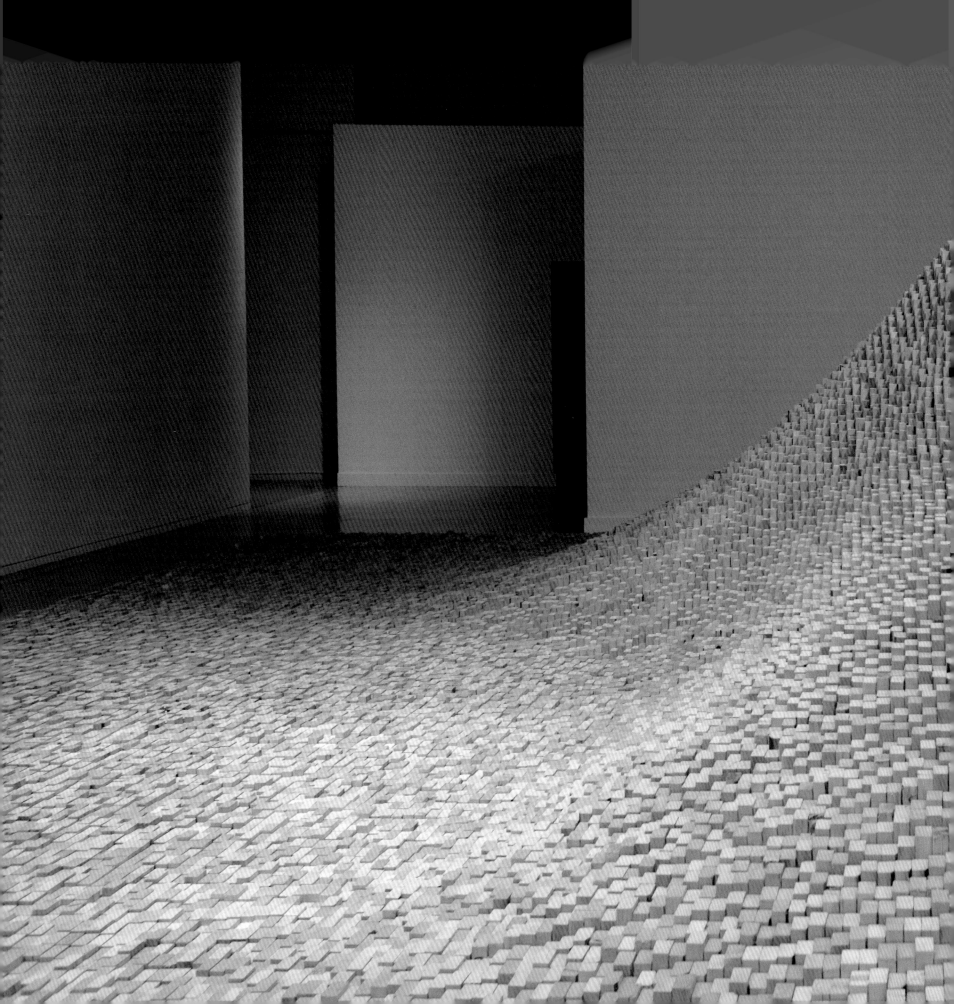

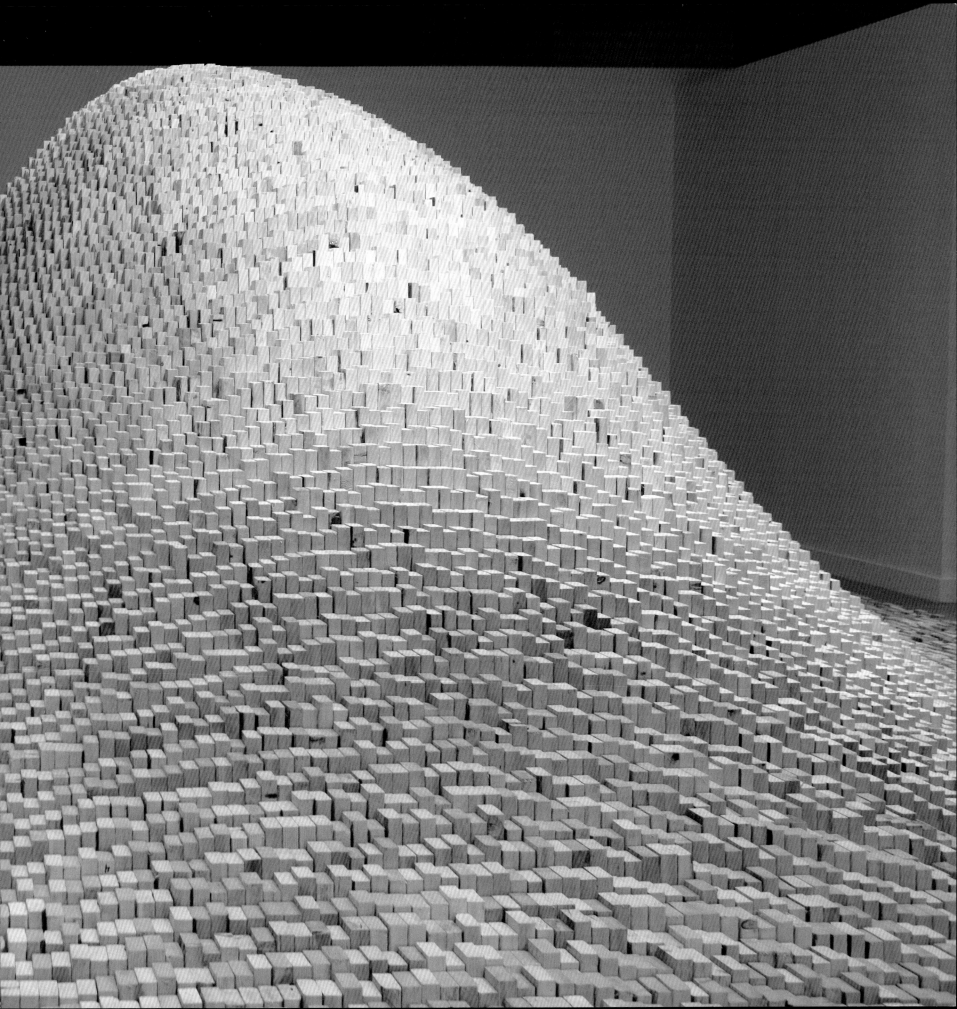

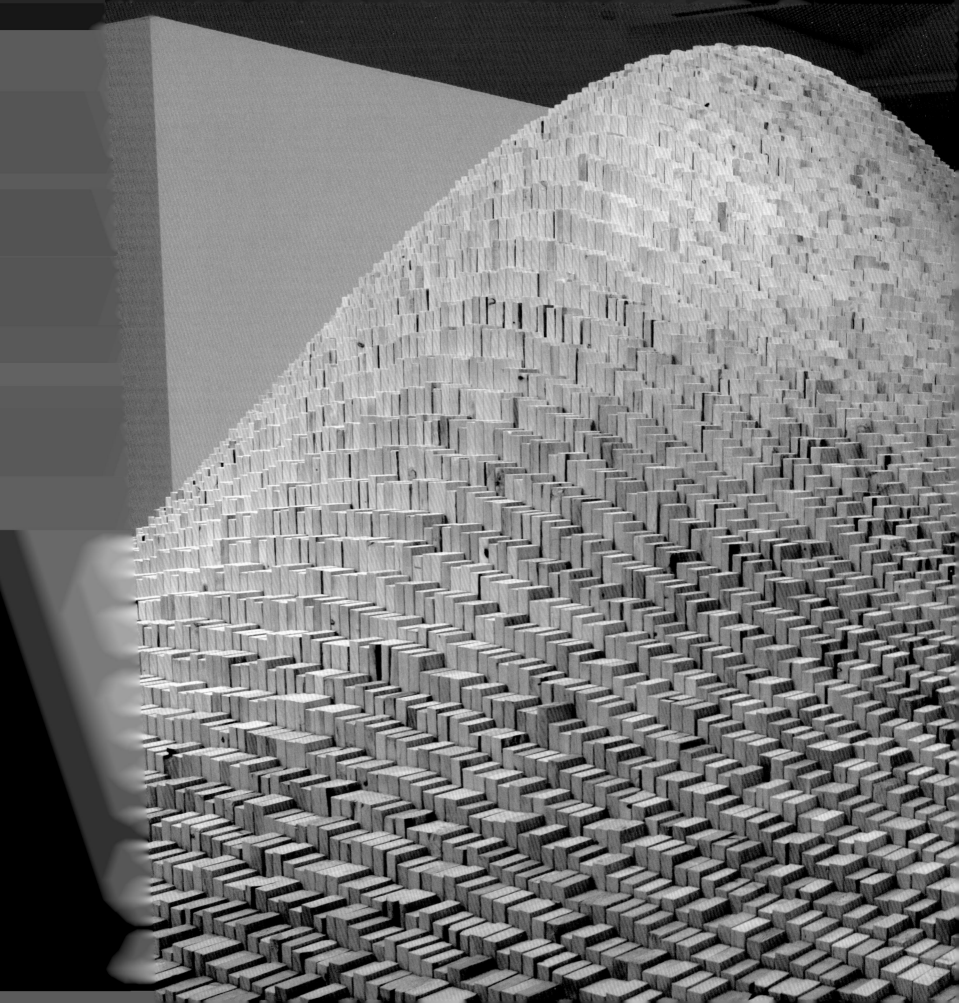

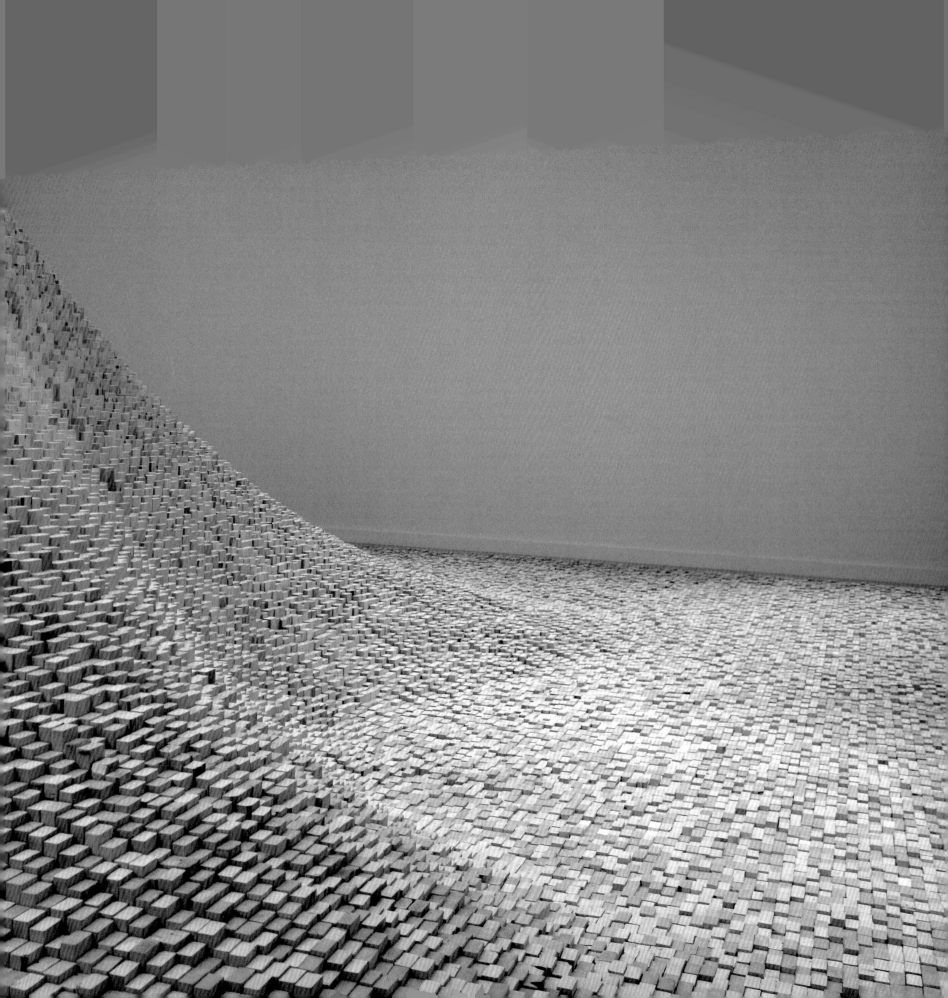

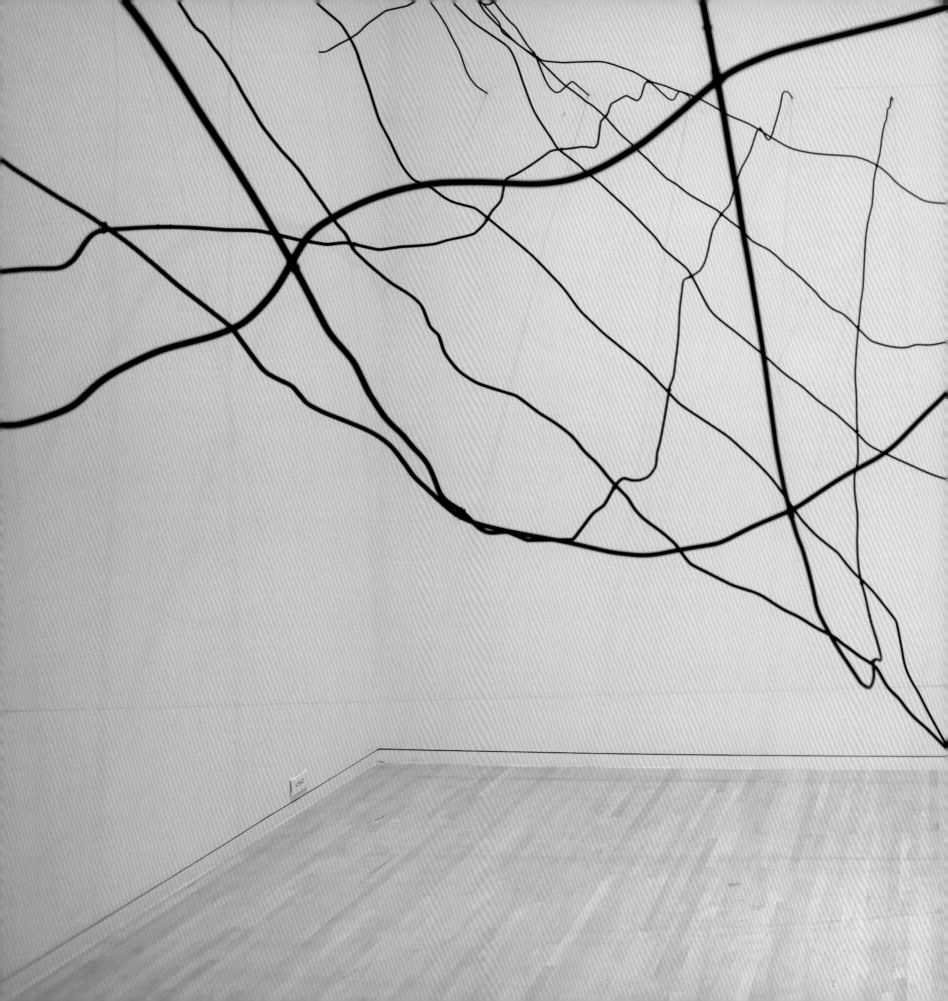

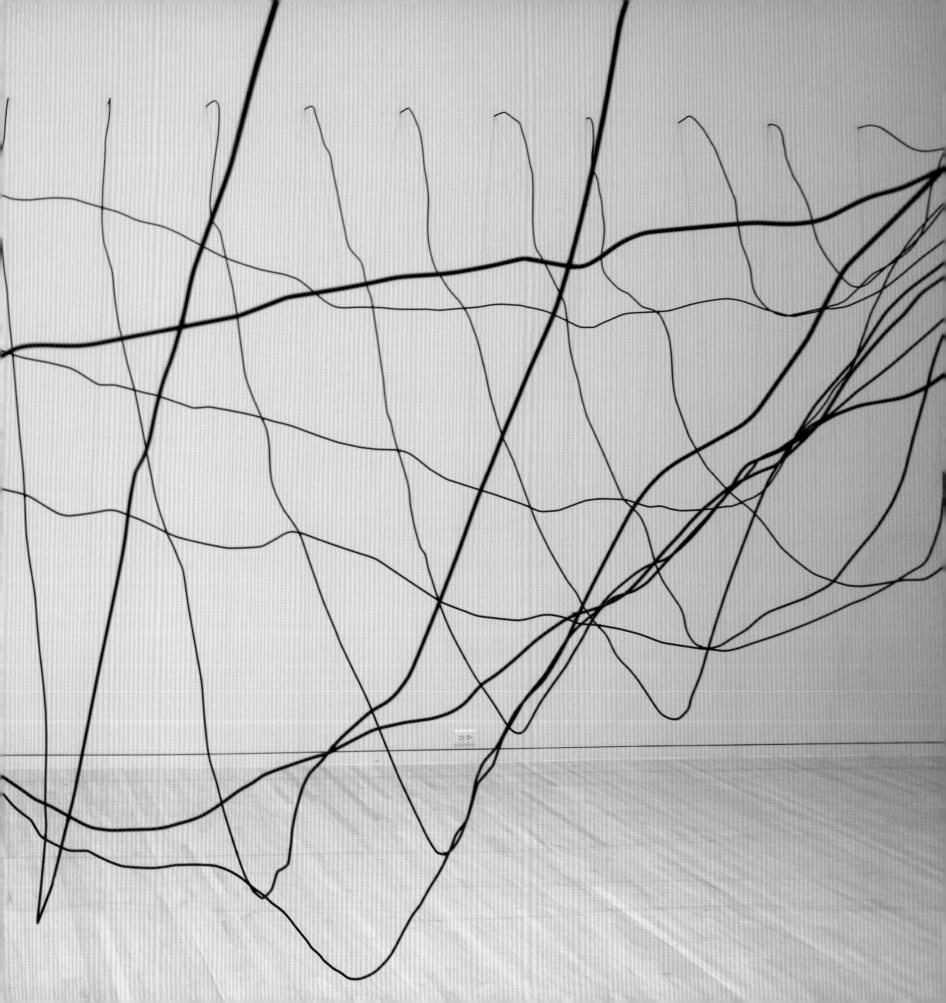

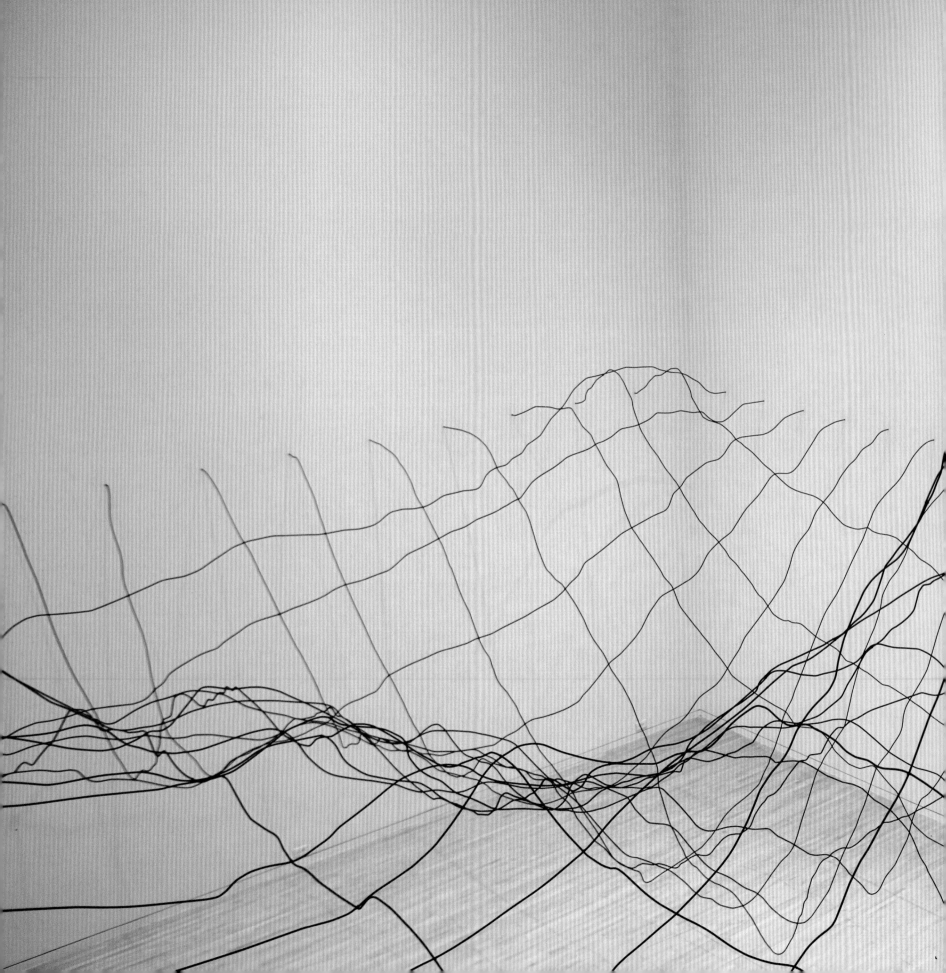

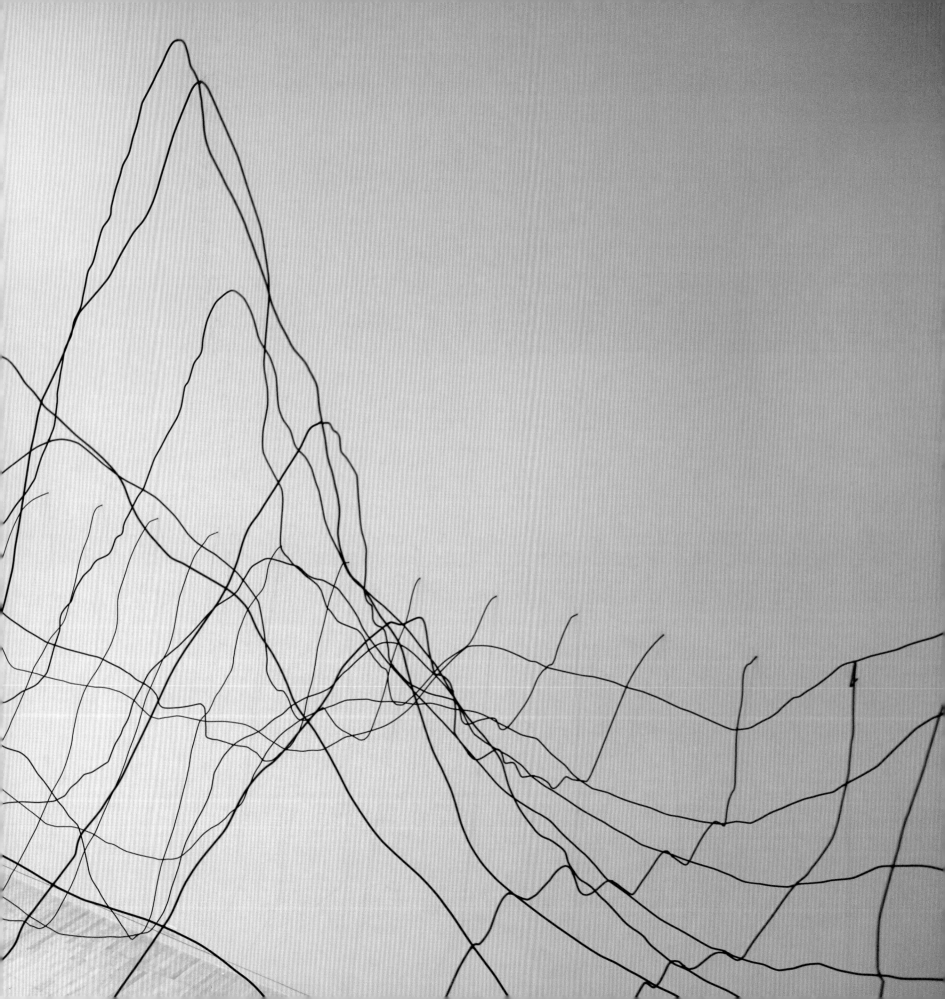

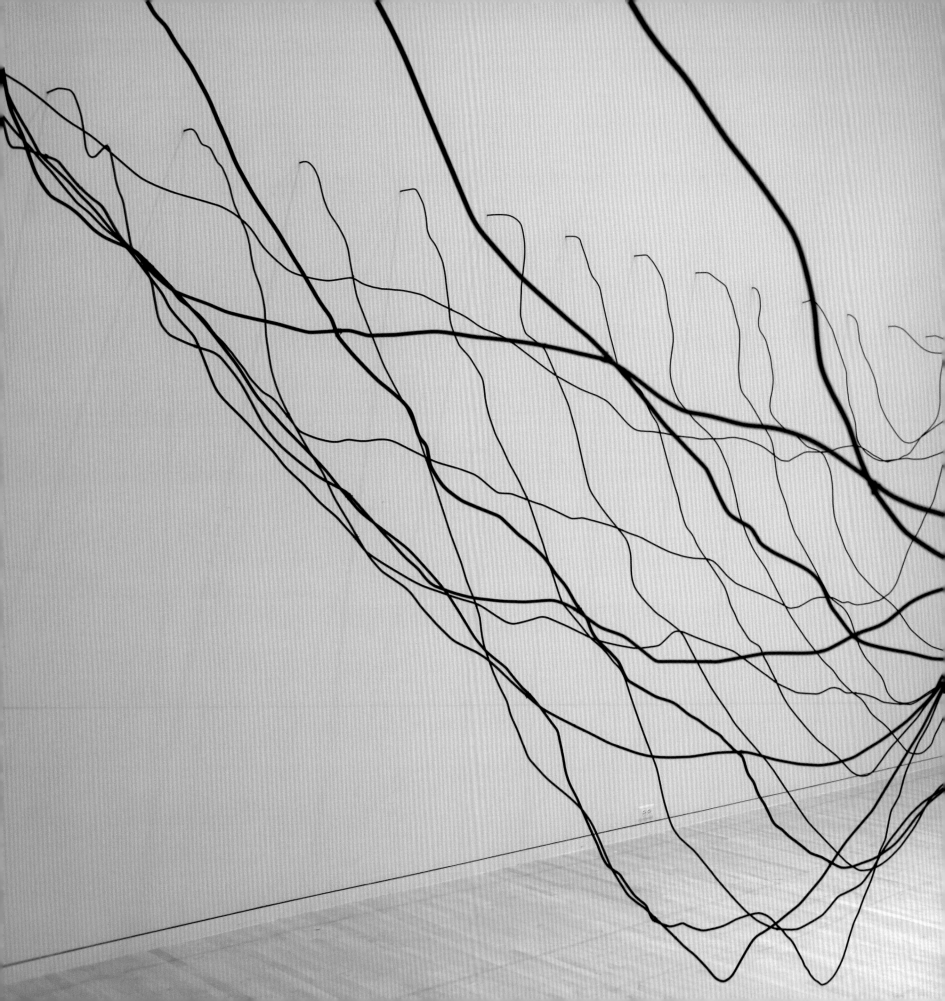

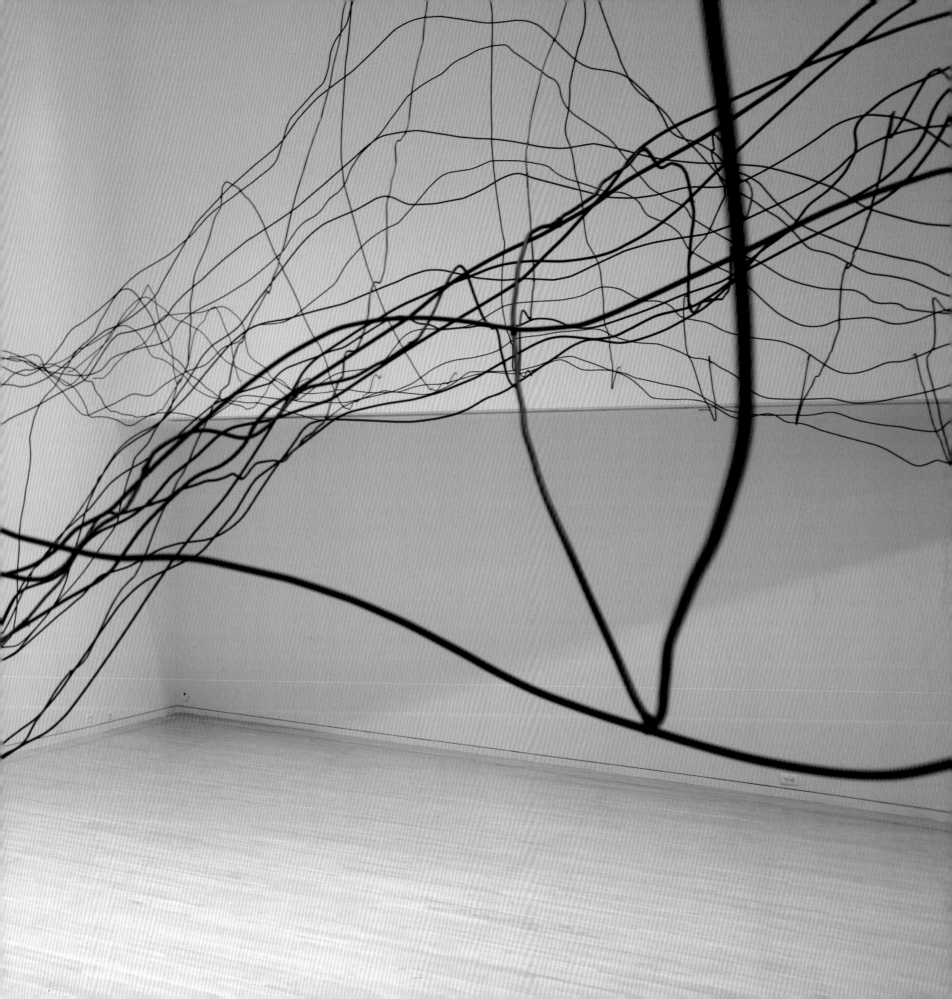

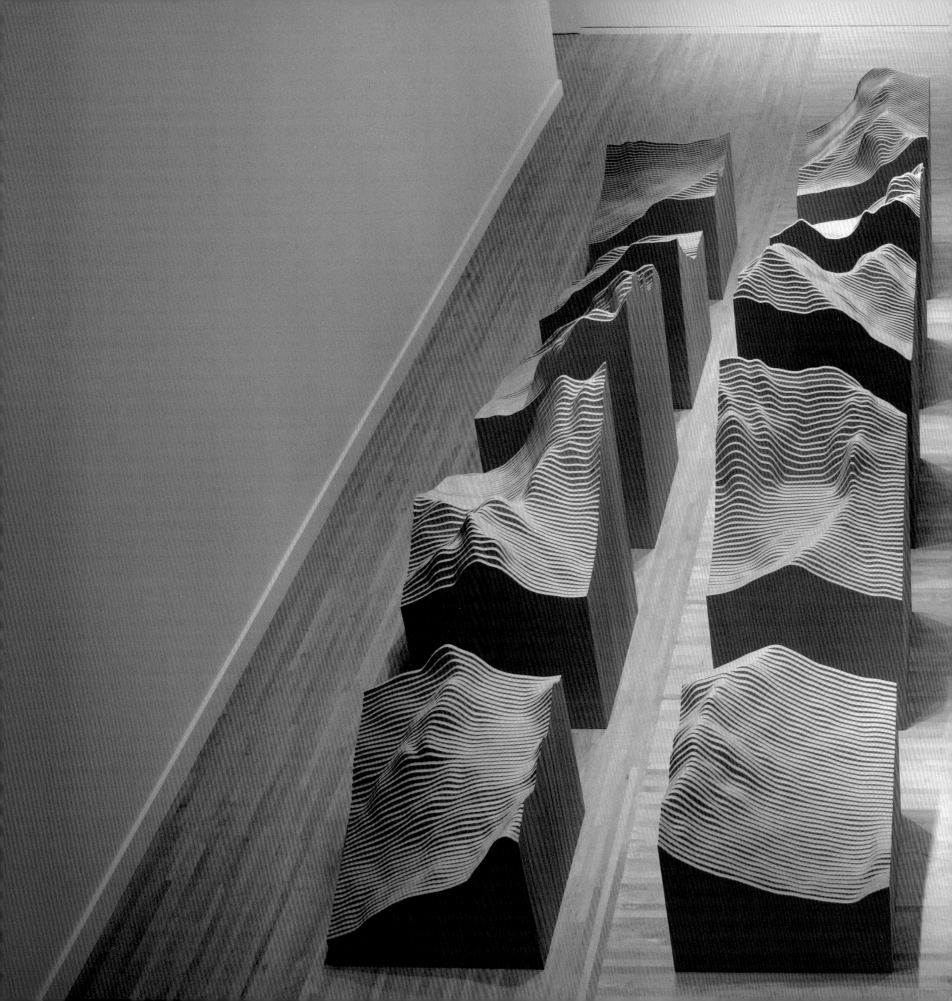

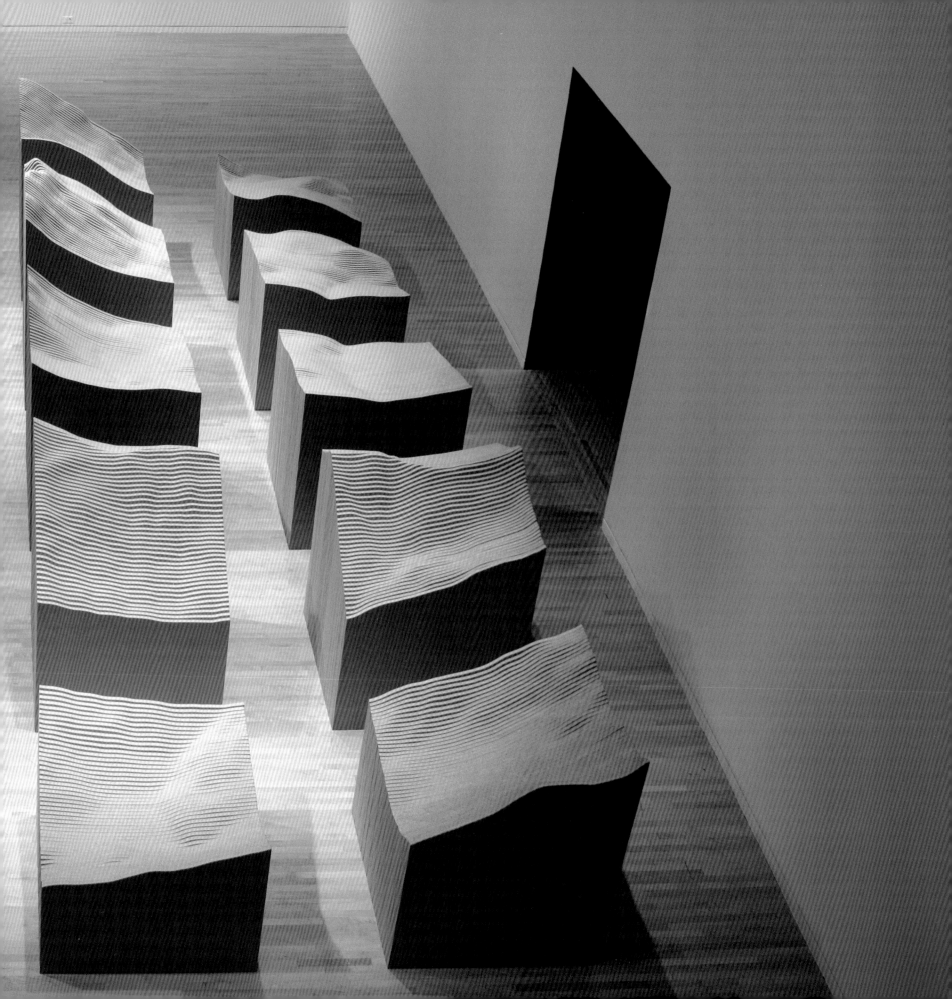

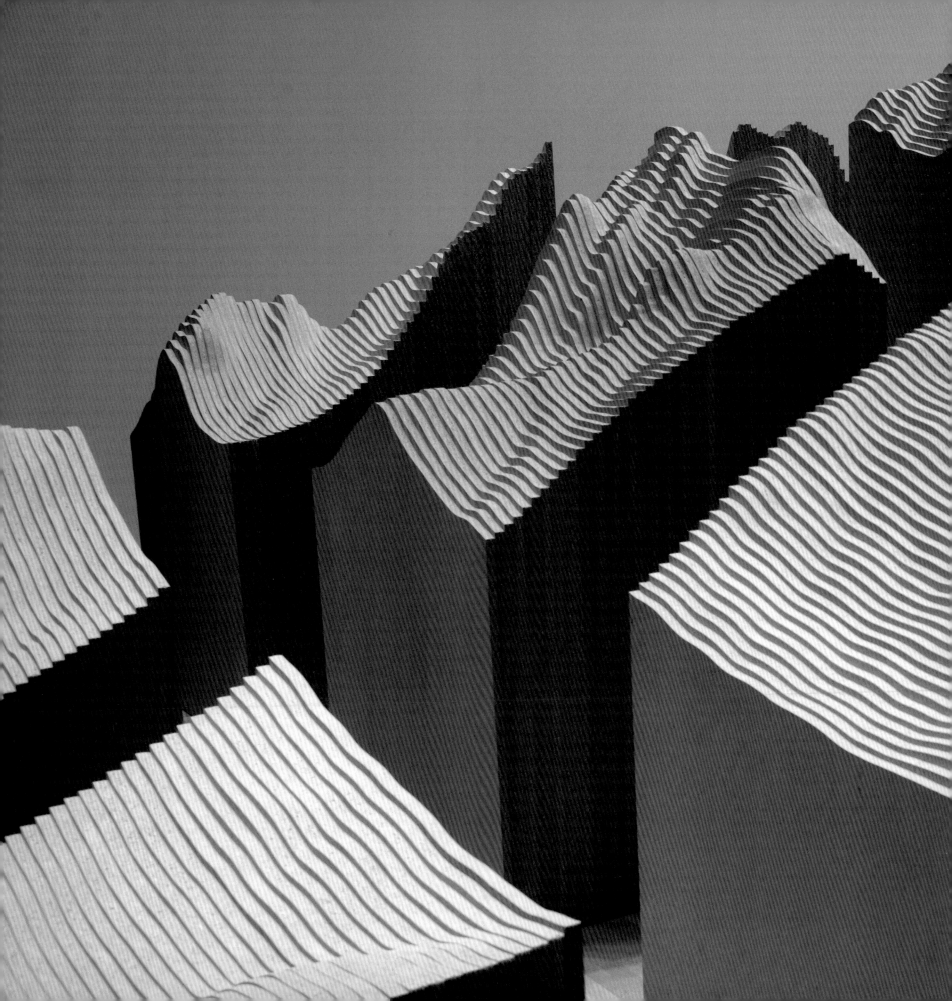

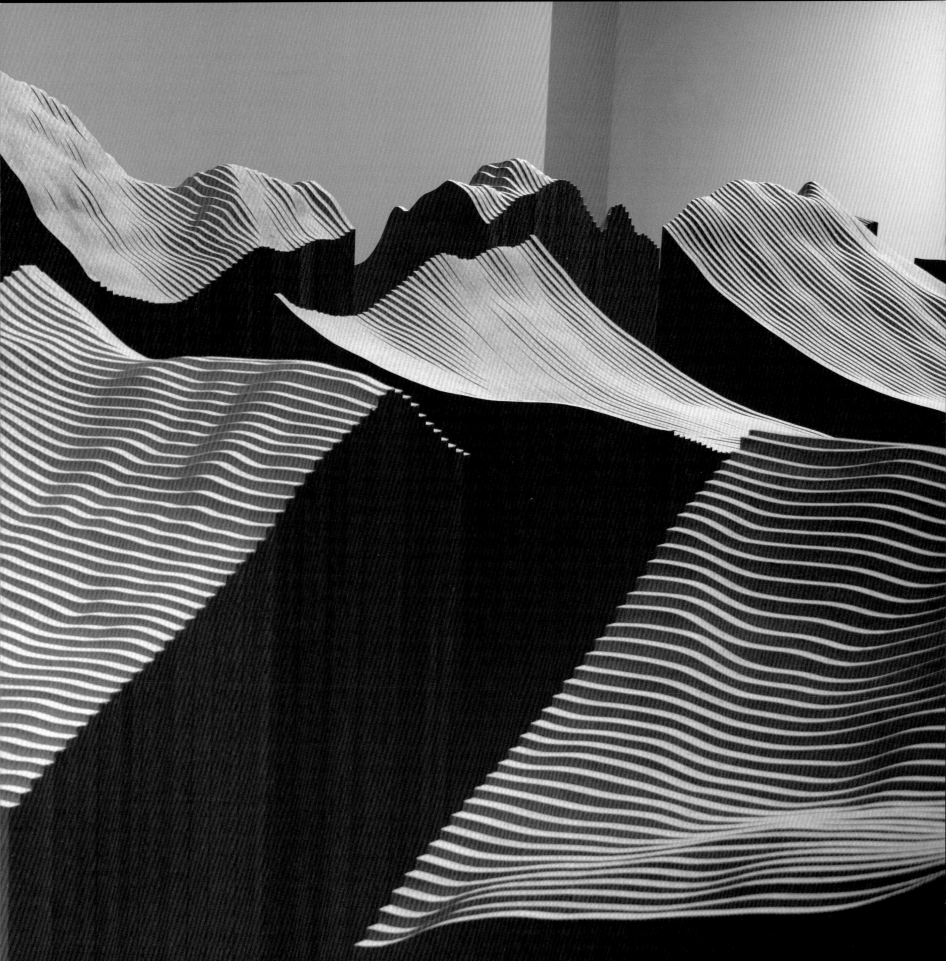

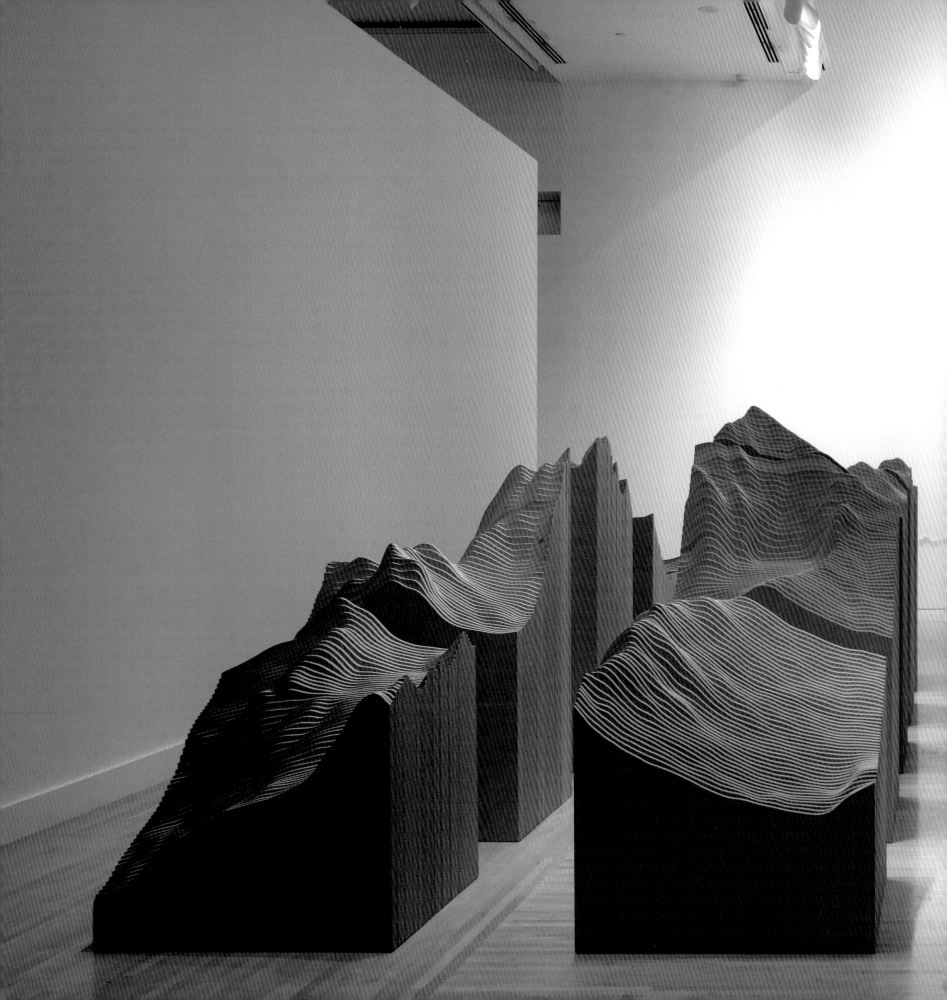

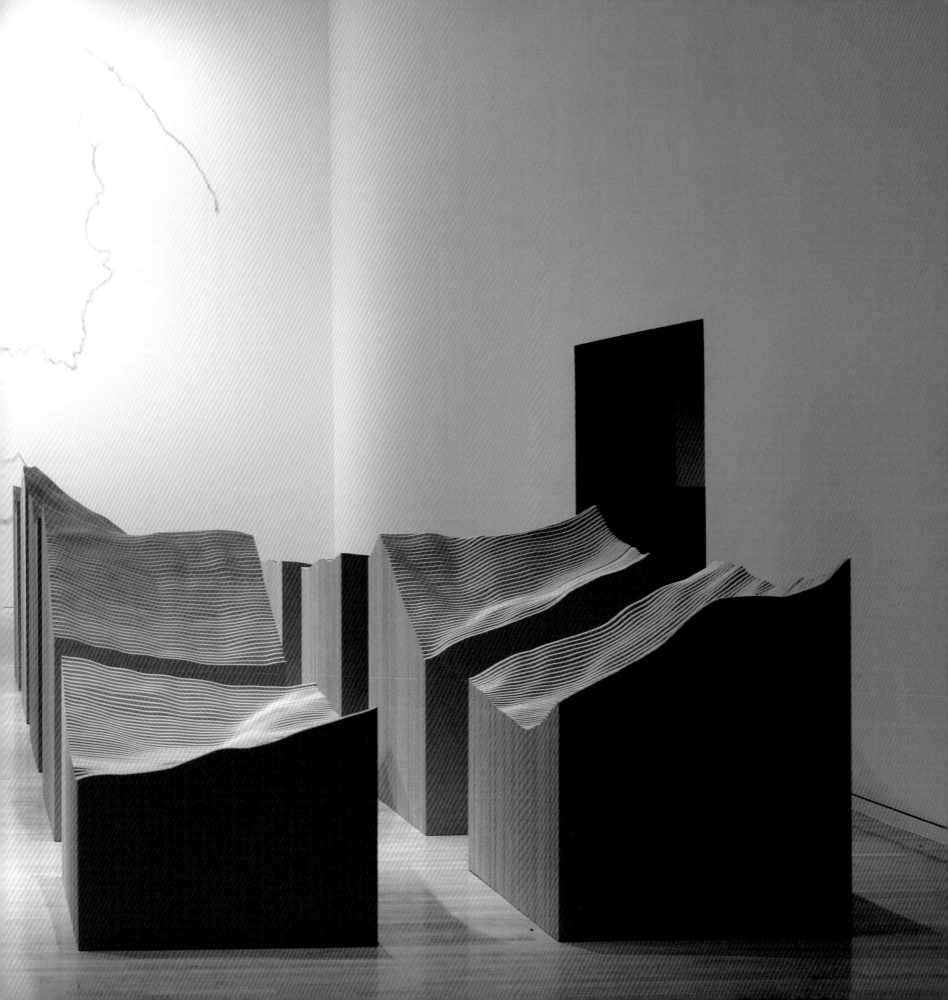

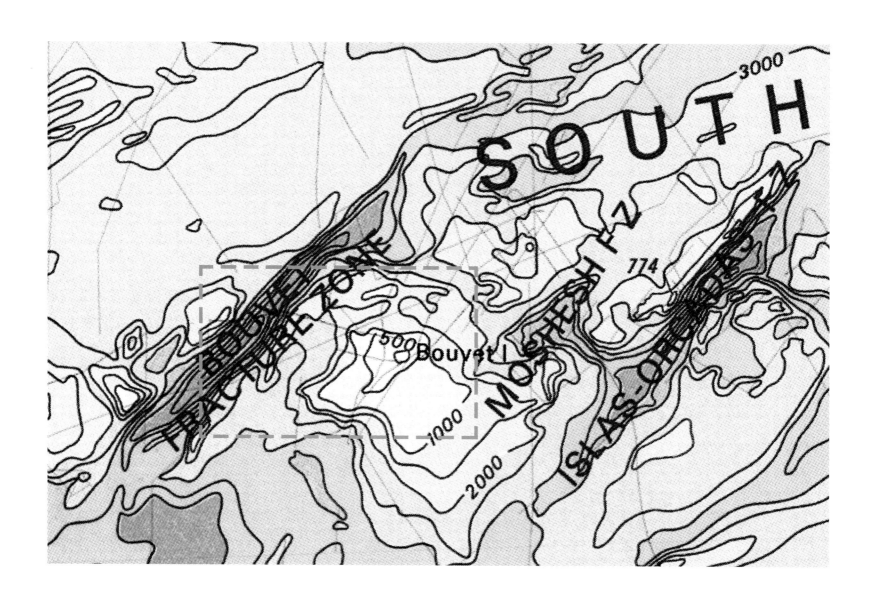

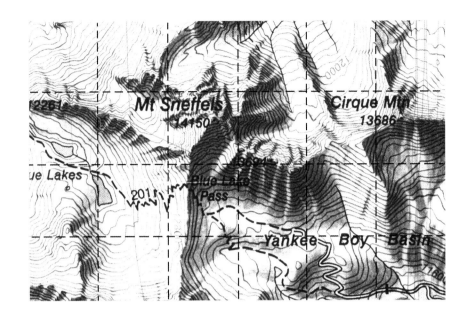

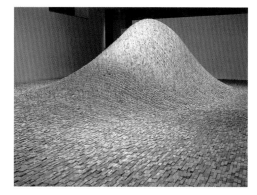

2 x 4 Landscape

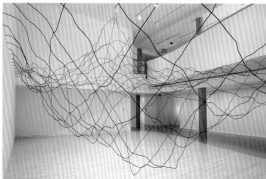

Water Line

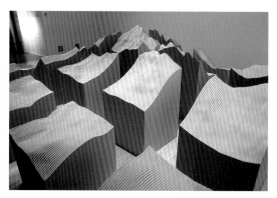

Blue Lake Pass

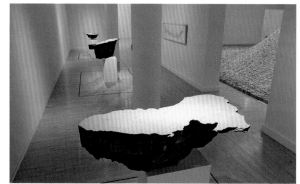

Bodies of Water

Pin River–Columbia

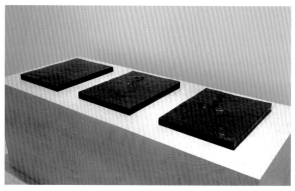

Earth Drawings

Fractured Landscapes

Untitled (*Plaster Relief Landscapes*)

Wire Landscape

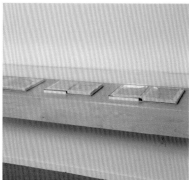

Atlas Landscapes

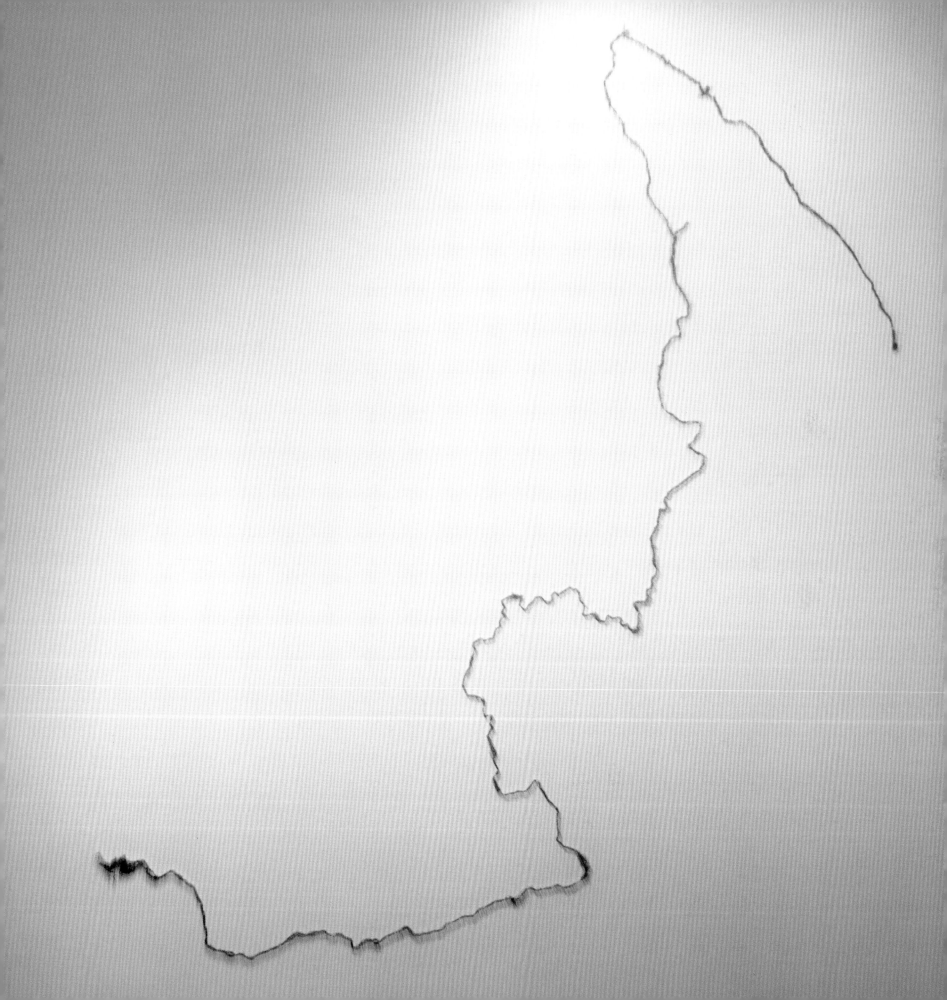

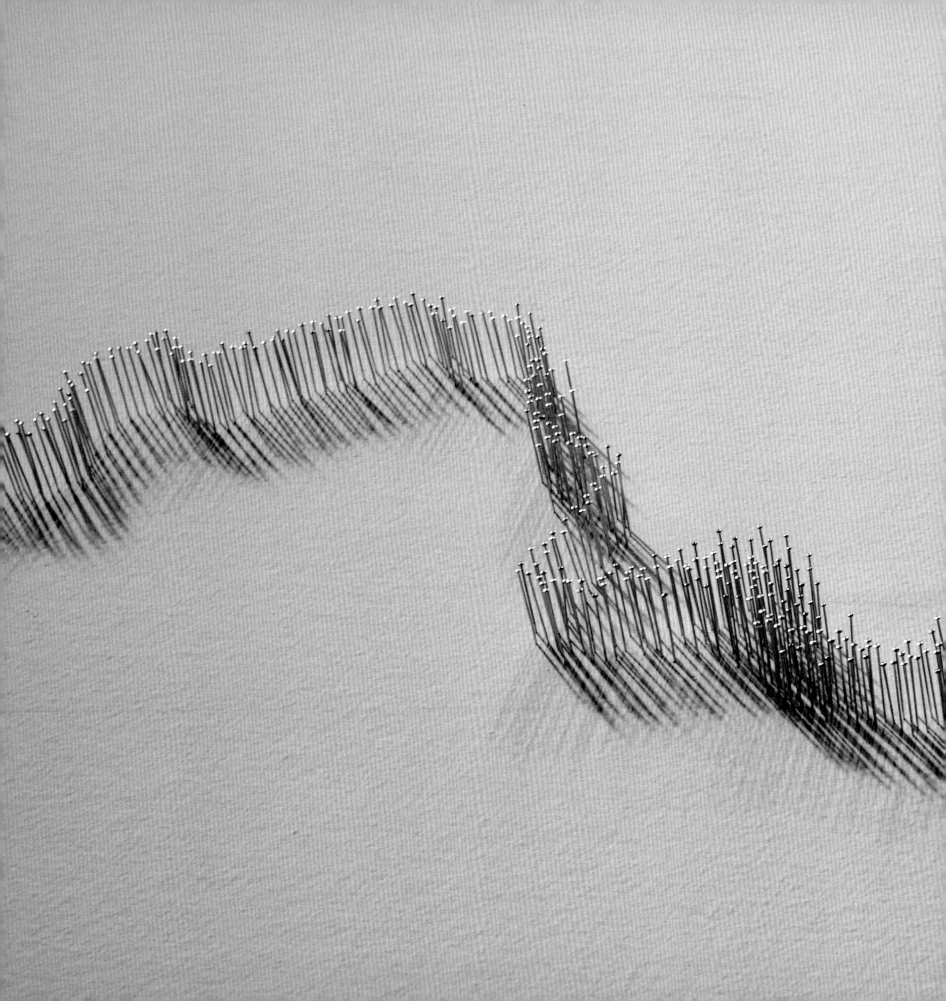

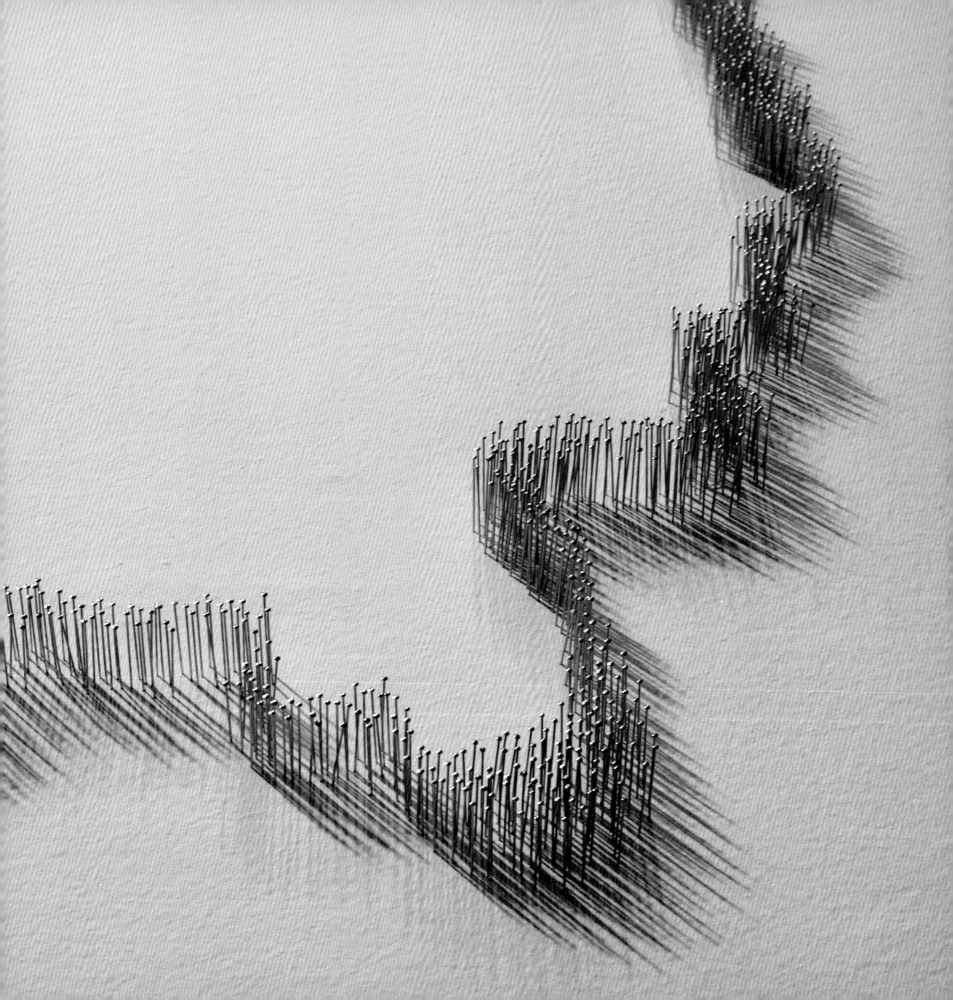

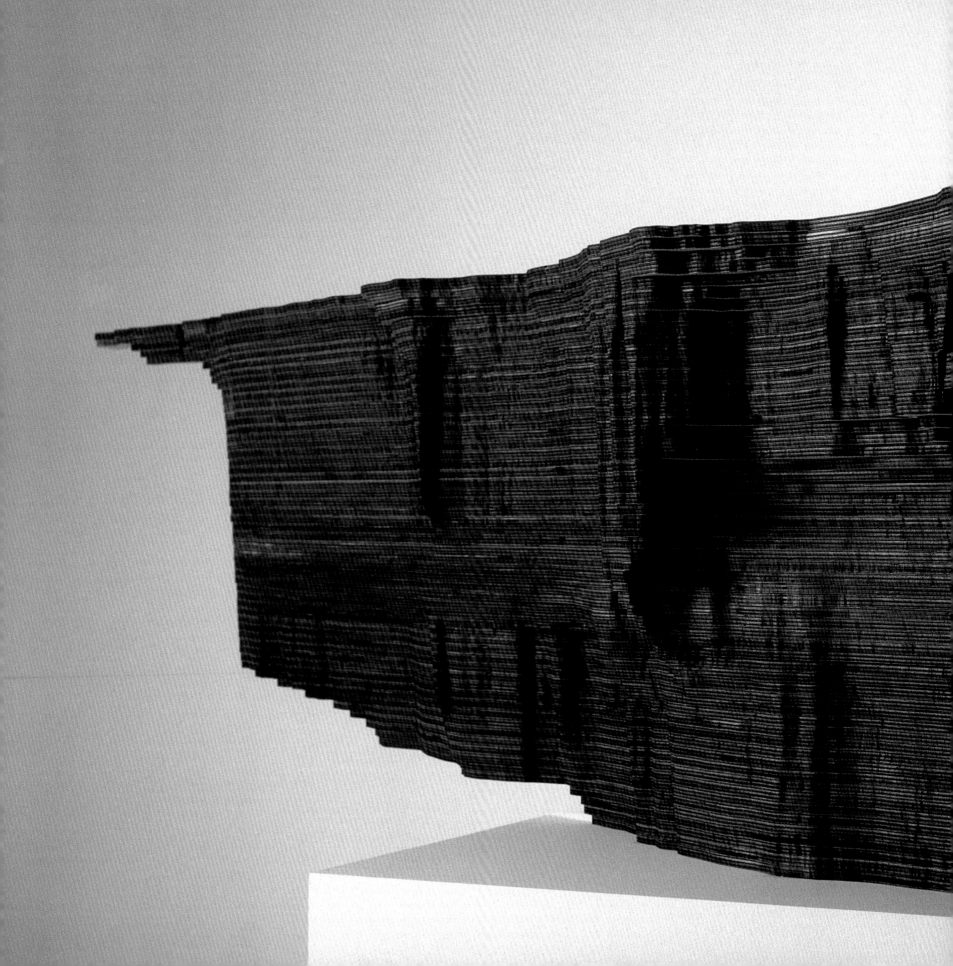

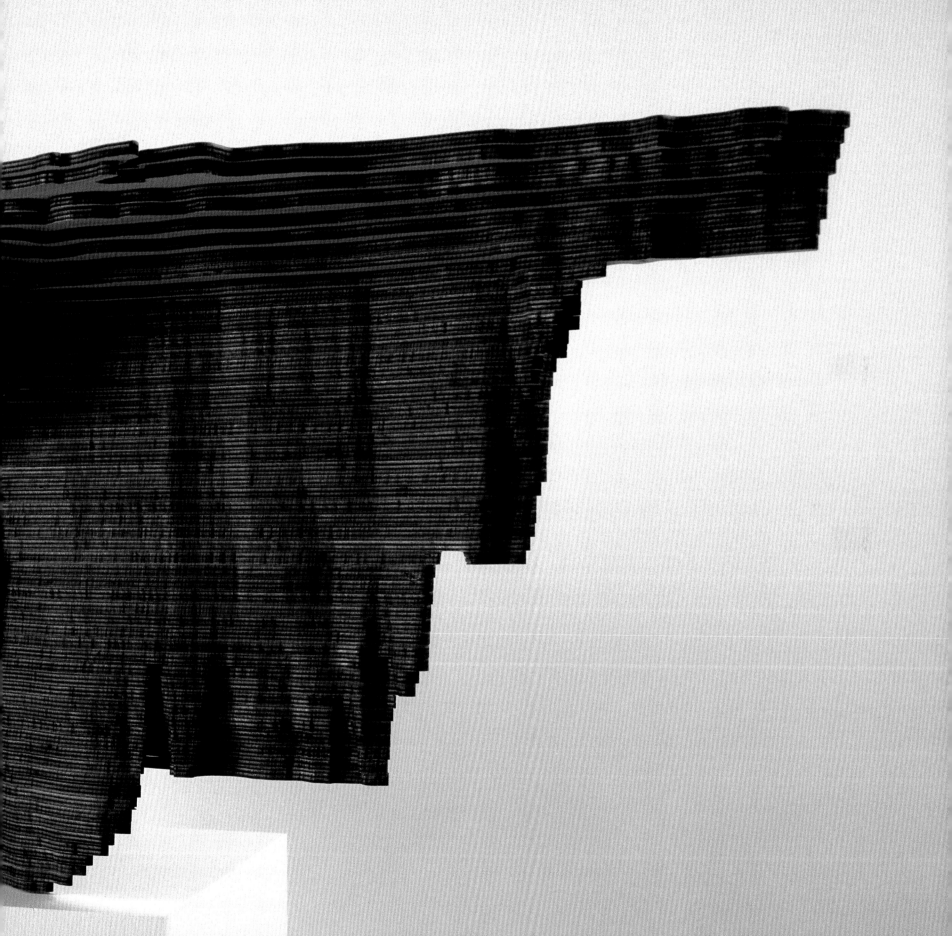

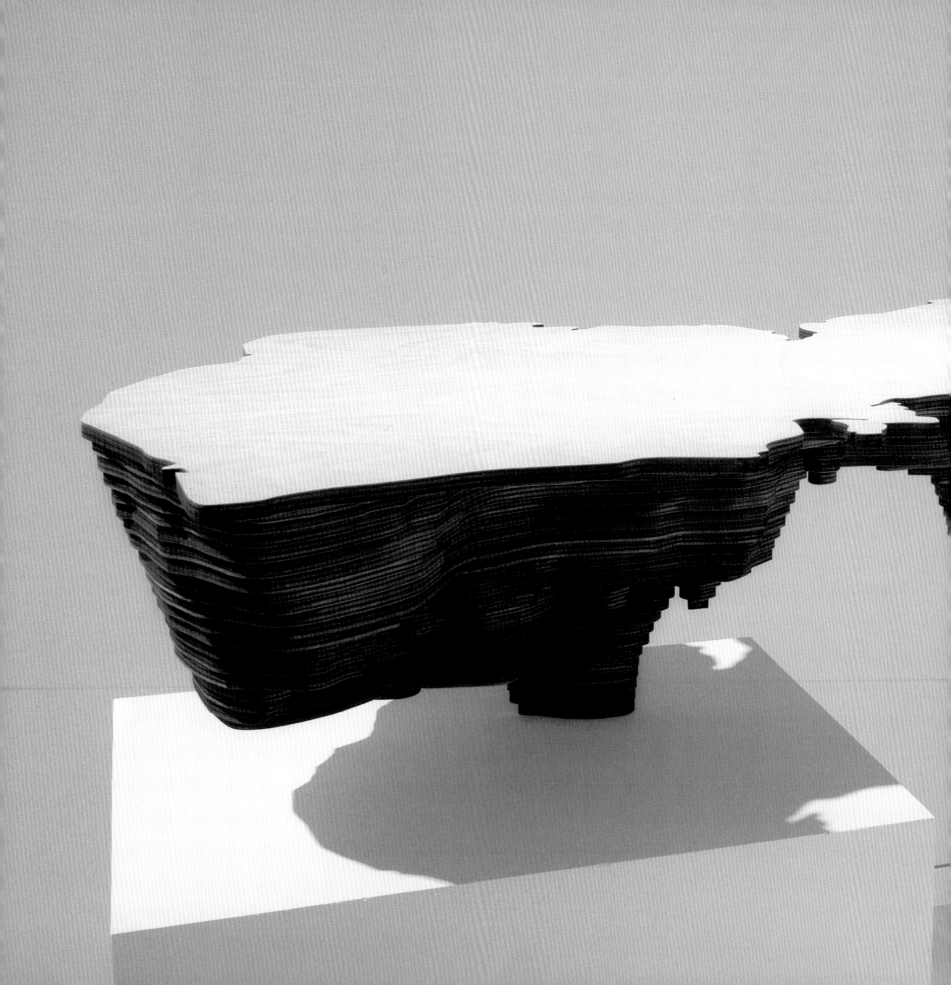

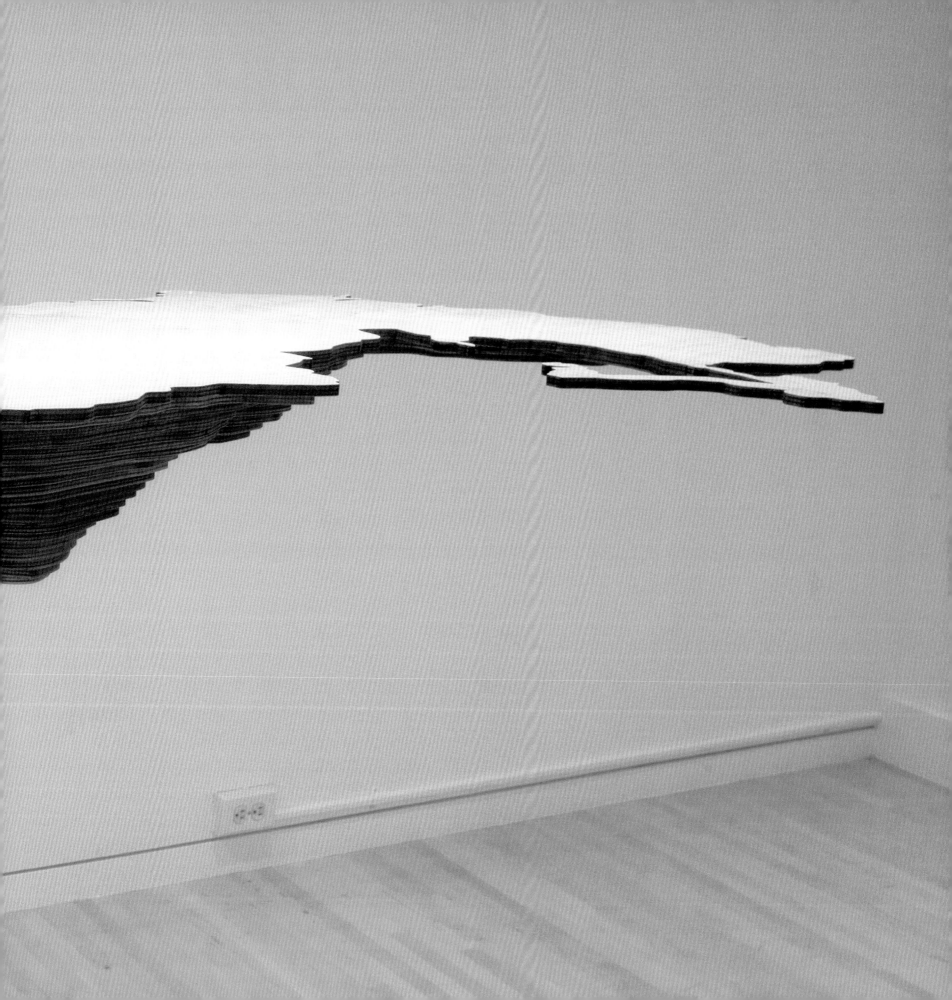

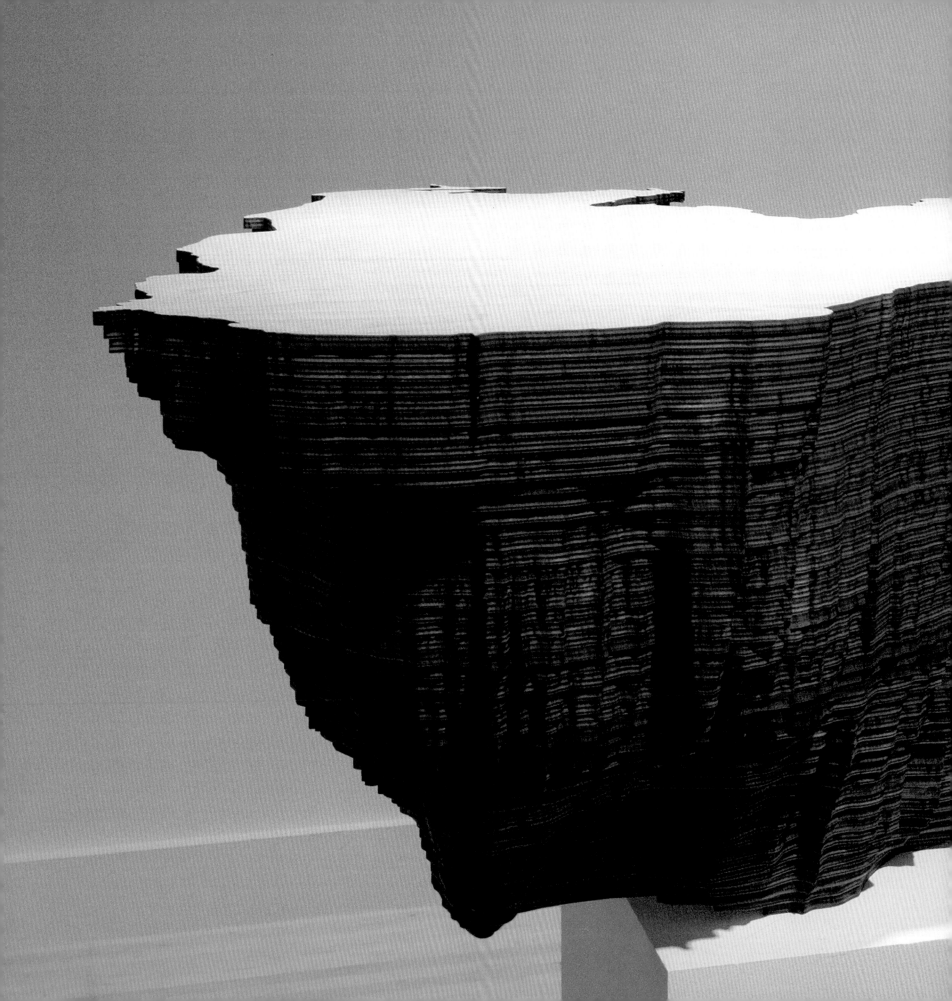

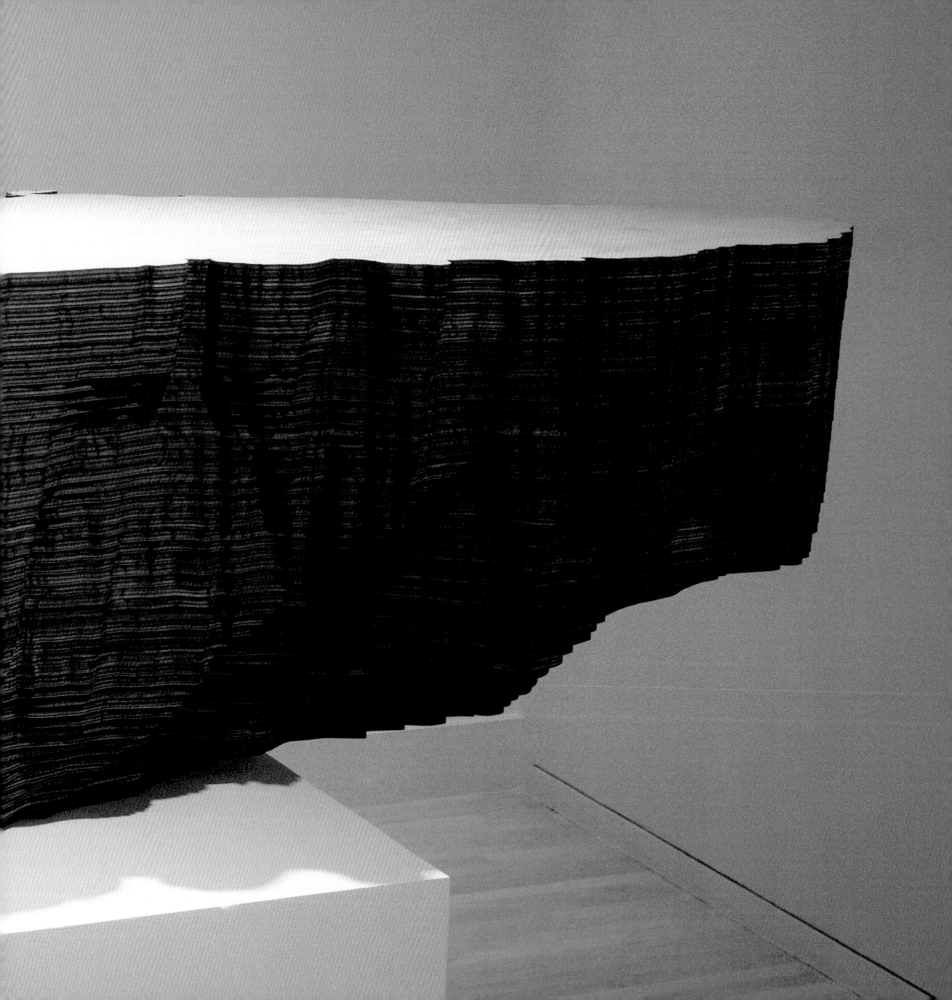

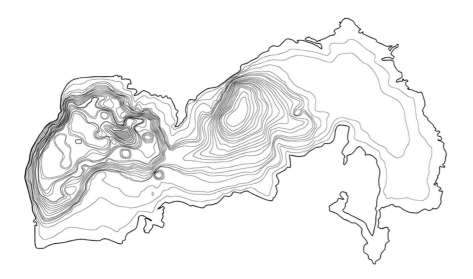
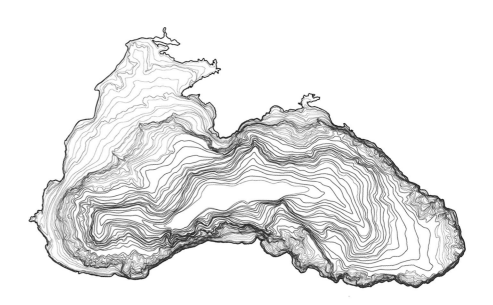

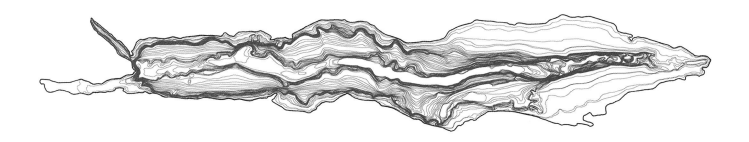

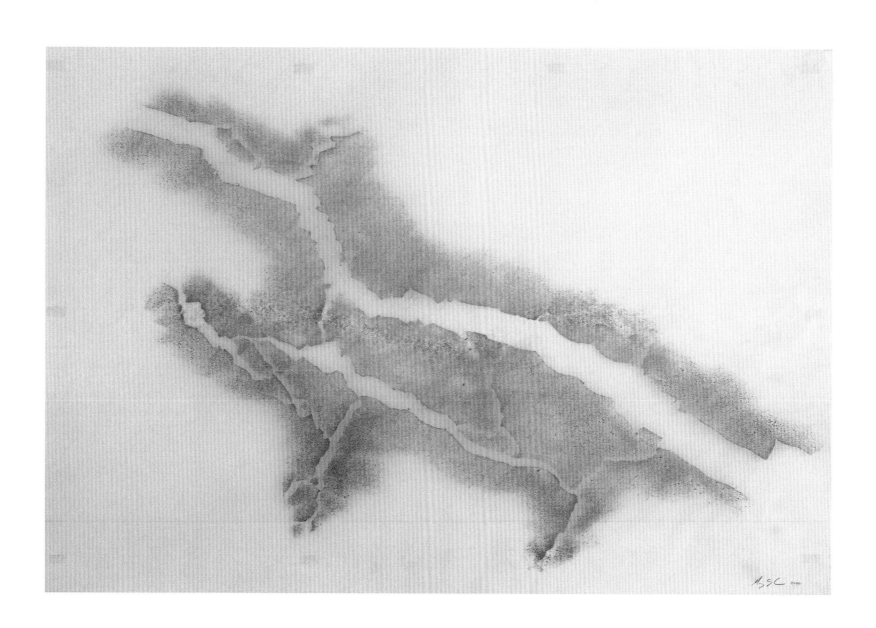

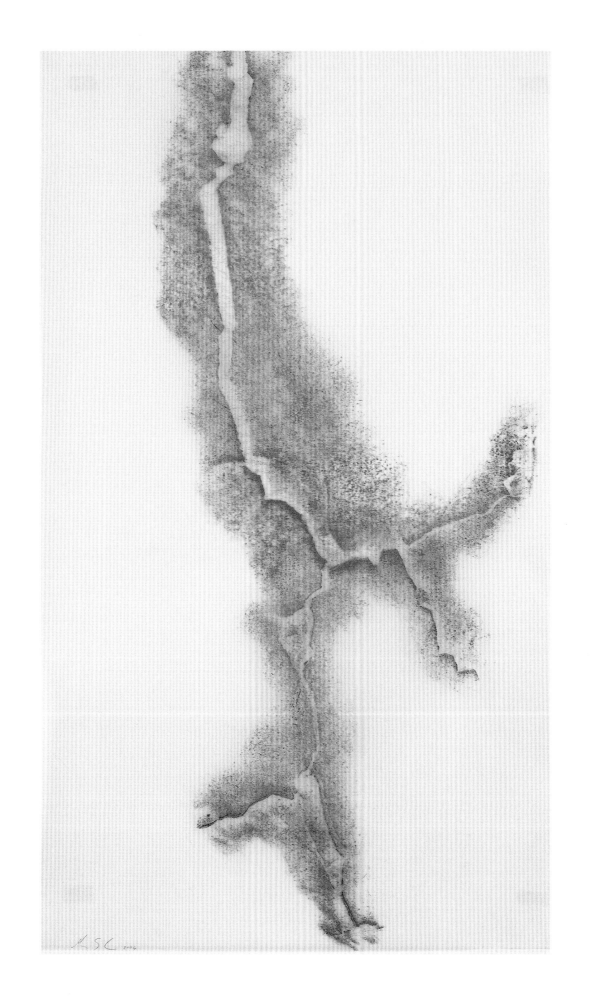

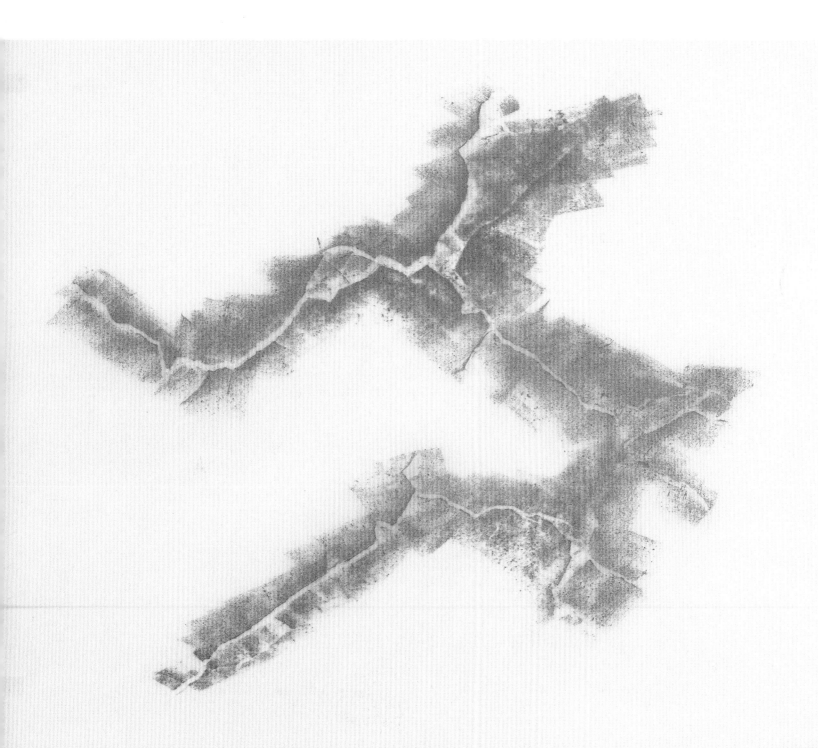

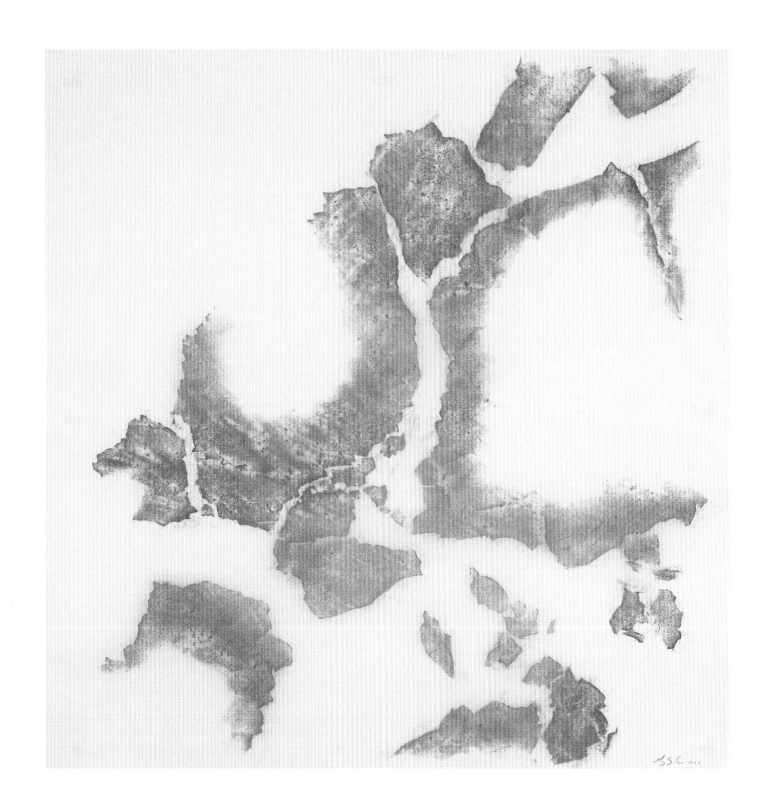

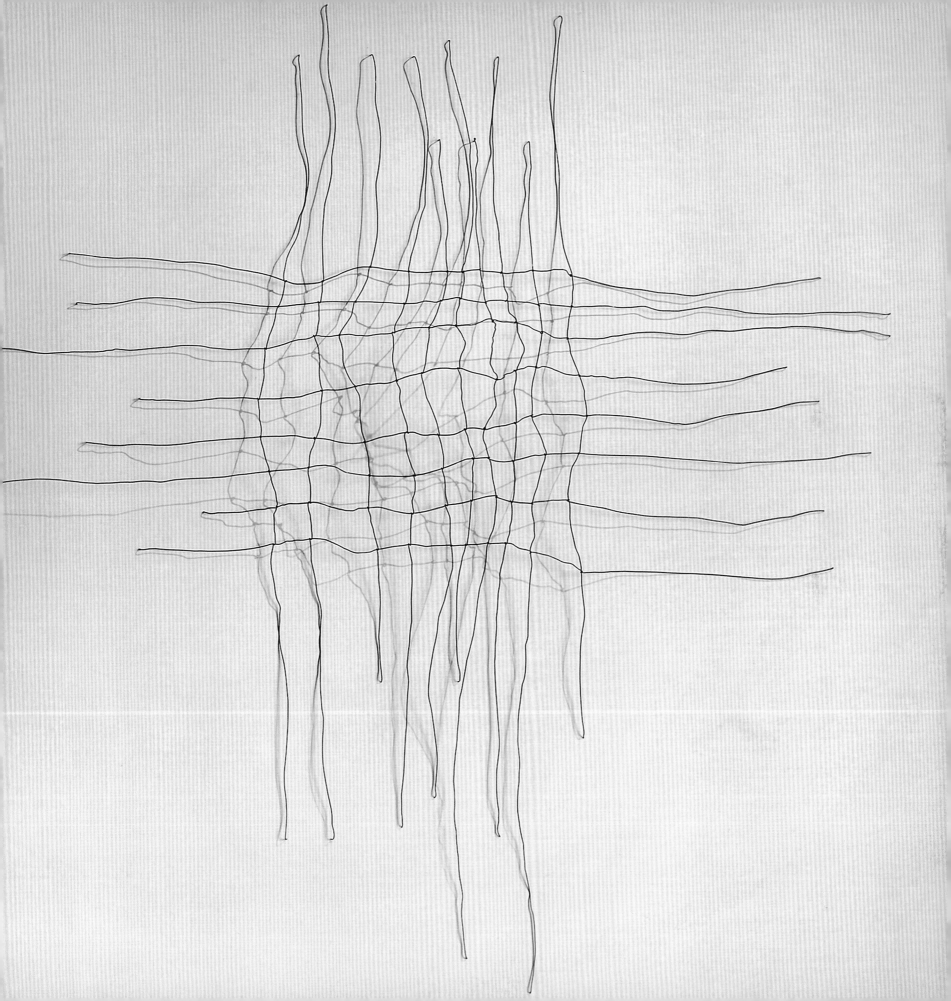

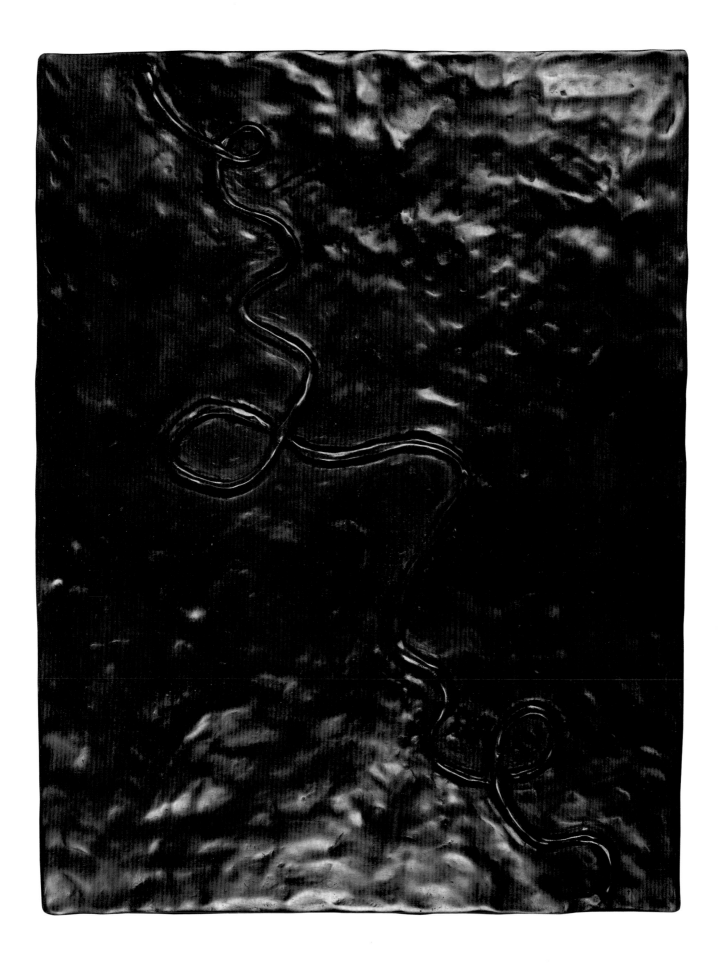

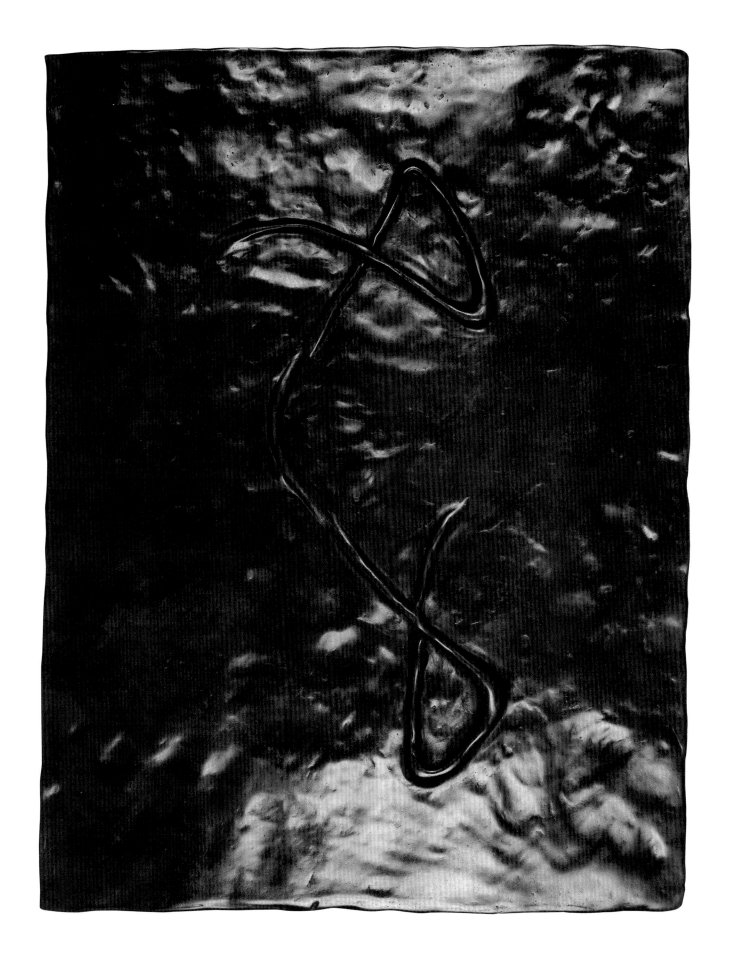

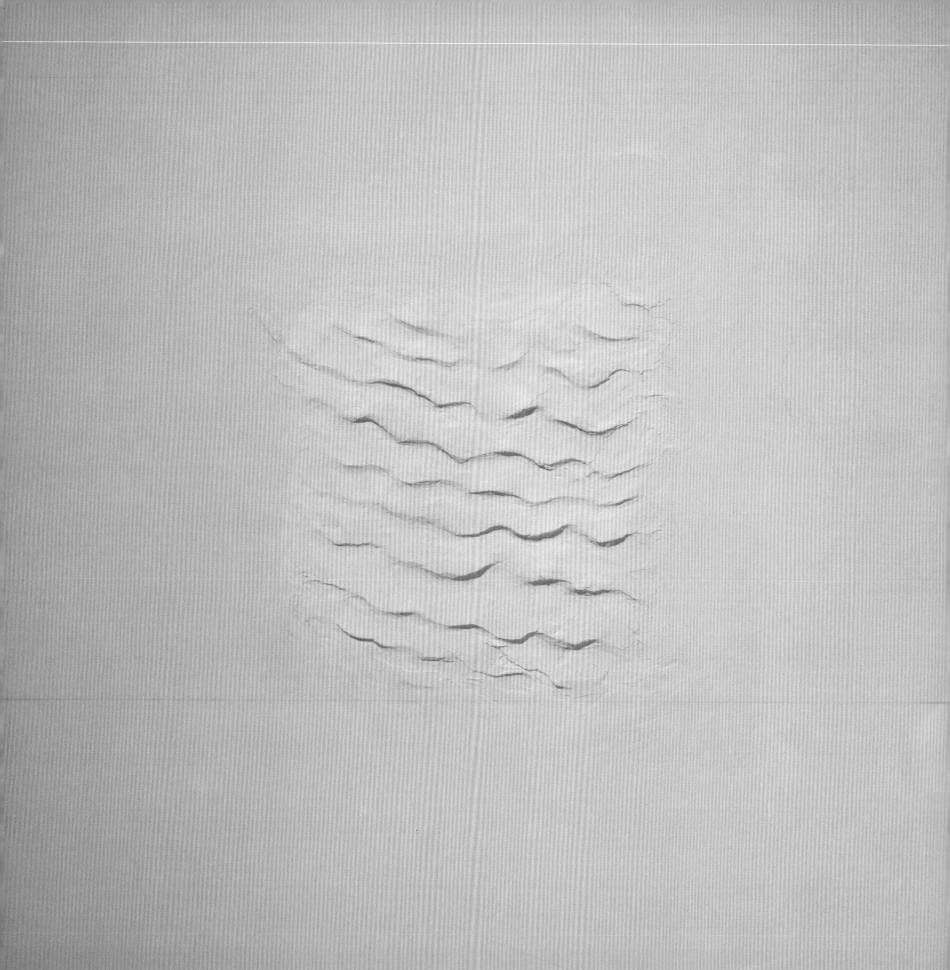

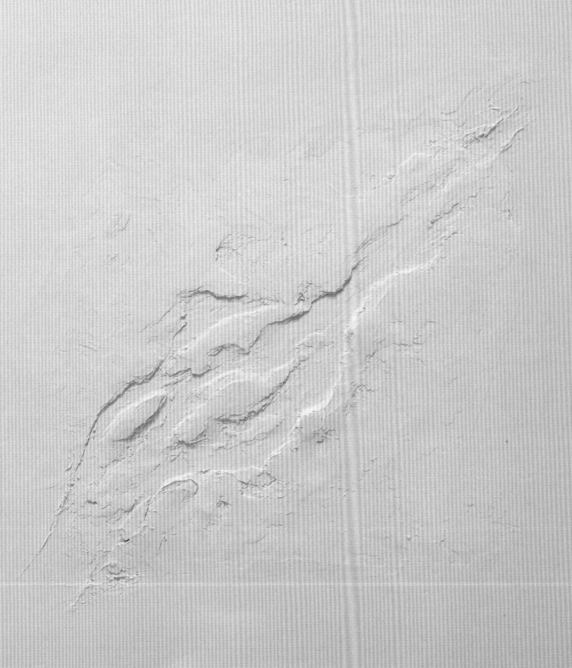

43

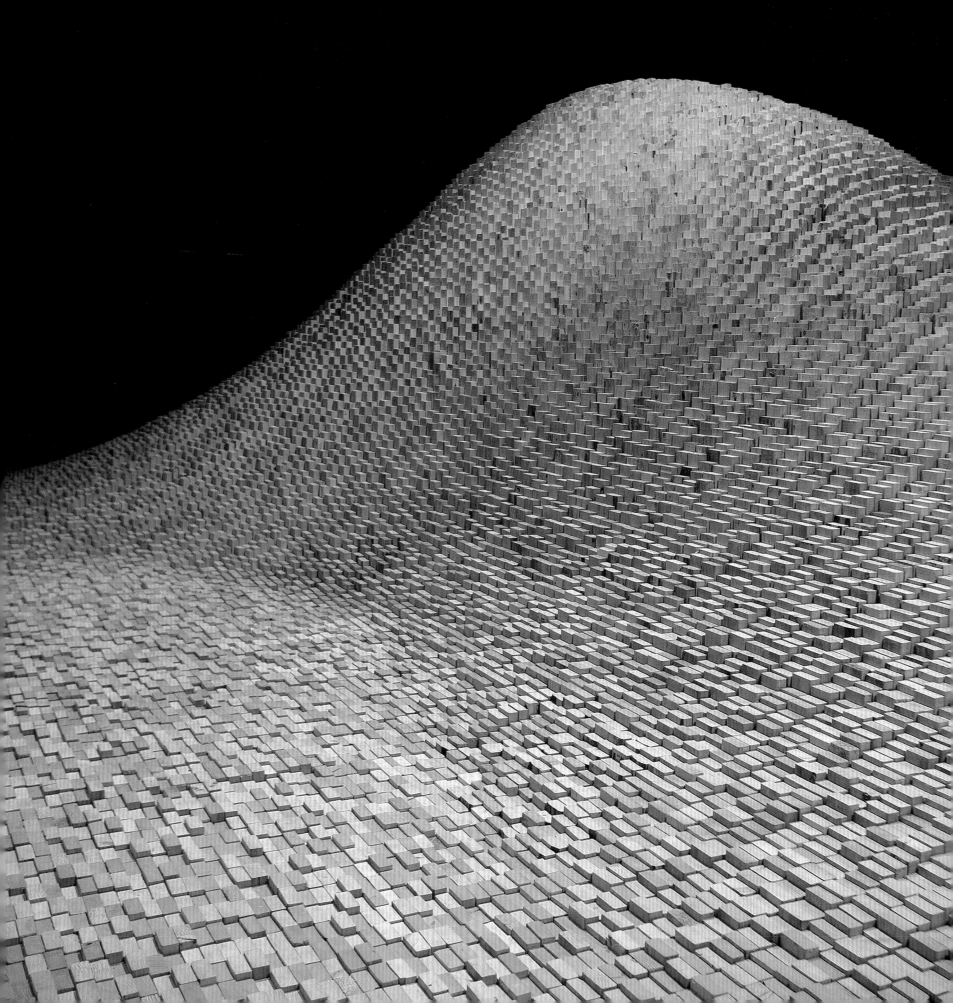

Seeing Maya Lin's *2 x 4 Landscape* for the first time is a shock. Tens of thousands of cut boards on end create a commanding sculpture that swells to ten feet high in a sensuous curve. The form is strikingly familiar; the context is not. The shape is something between a wave and a hill, but the texture and materials are those of the built environment, not nature. It is a beautiful and unsettling experience, an encounter with a work of art that embodies the idea of landscape within the space of architecture. It feels as if a natural formation had accreted over time within the building, board by board and layer by layer. The sublime made from the prosaic and the outside in.

SYSTEMATIC LANDSCAPES

Systematic Landscapes presents a new body of work Maya Lin has formulated since her 1998 exhibition *Topologies*. The exhibition provided an opportunity for Lin to realize large- and small-scale works that utilize a language of natural forms (mound, wave, river, mountain, sea) and systems for reading landscape (model, grid, and topographic drawing) to bring the experience of landscape to the space of architecture. In her introductory statement for *Systematic Landscapes*, she said:

> *This exhibition continues my interest in exploring notions of landscape and geologic phenomena.*
>
> *The works created, both small-scale and large-scale installations, reveal new and at times unexpected views of the natural world: from the topology of the ocean floor, to the stratified layers of a mountain, to a form that sits between water and earth.*
>
> *Utilizing the way in which scientists and computers see our world, drawing on images based on sonar views of the ocean floor to aerial and satellite views of the land, I have started to create artworks that translate that technological view into sculptural forms. In so doing, I have begun to create works that present a somewhat systematized view of natural phenomena.*

In her writings and interviews, Lin emphasizes her relationship to nature as the foundation of all of her work.

> *A strong respect and love for the land exists throughout my work. I cannot remember a time when I was not concerned with environmental issues or when I did not feel humbled by the beauty of the natural world.*
>
> *I do not believe anything I can create can compare to the beauty of the natural world, but these works are a response to that beauty.*[1]

She seeks to create works, whether art, architecture, or monument, that offer a point of entry into our experiential relationship with the natural world. Her work is predicated on the belief that a connection to nature is an essential component of our humanity.

Outside In: Maya Lin's Systematic Landscapes

Richard Andrews

But nature is not the same as landscape. Landscape might be thought of as the visual evidence of nature's complex processes, and Lin uses a vocabulary of familiar forms drawn from landscape to heighten our awareness of nature. When we speak of a landscape, we are using the term as a means to break down the world into more manageable pieces, whether vignette, vista, or region. Landscape can be literally what we see in front of us (a blooming cherry tree in a garden) or what stretches over the horizon (the American West). Lin's large-scale works explore how our understanding of landscape is framed by personal experience with the natural world. Such knowledge is, of necessity, fragmentary, based on relationships to particular landscapes, and leads us to recognize that we can never fully understand nature, in much the same way that we cannot completely comprehend consciousness, because we exist within it.

In his book *Space and Place,* the geographer Yi-Fu Tuan insightfully describes the centrality of experience in understanding our relationship to the world outside of our self.

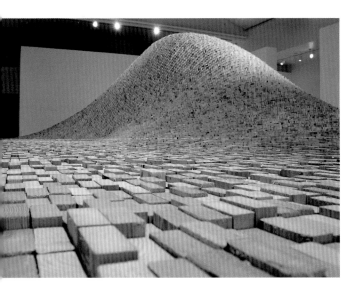

2 x 4 Landscape

> *Experience is compounded of feeling and thought. Human feeling is not a succession of discrete sensations; rather memory and anticipation are able to wield sensory impacts into a shifting stream of experience so that we may speak of a life of feeling as we do of a life of thought. It is a common tendency to regard feeling and thought as opposed, the one registering subjective states, the other reporting on objective reality. In fact, they lie near the two ends of an experiential continuum, and both are ways of knowing.*[2]

As an environmental artist, Lin creates works that invite physical and mental exploration, making full use of Tuan's experiential continuum. Her interest in the connection between feeling and thought, interior and exterior, art and design, is given voice in the opening lines of her book *Boundaries:*

> *I feel I exist on the boundaries. Somewhere between science and art, art and architecture, public and private, east and west. I am always trying to find a balance between these opposing forces, finding the place where opposites meet.*[3]

Lin's choice to seek balance points, moments of harmony, lies at the heart of her work as an artist.

How to systematize landscape? Yi-Fu Tuan's suggestion that experience is "compounded of feeling and thought" gives us a possible answer as it suggests a linkage between analysis and perception. On one hand are the tools of classification and visualization, including mapping and other ways of "seeing" landscape, and on the other, the memories we carry of firsthand experience with the hills, valleys, mountains, deserts, lakes, rivers, and oceans that make up our world.

Seeing and recording landscape has occupied many artists and scientists for centuries. Making sense of the world around us, by noting landmarks and patterns, has preoccupied humans from the beginning. Nature might be overwhelming in its immensity and complexity, but framed views in the form of landscape descriptions and depictions are achievable. Looking at the night

sky, away from city lights, we cannot stop ourselves from connecting the dots and mapping the heavens. In the immensity of the universe we have only a point of view (literally a point, the earth, from which we view) and therefore we diligently set out to locate ourselves.

Our innate ability to locate our place in the world is quite remarkable. We rely on experience and memory to create modes of representation, such as maps or computer visualizations. Scientific exploration has developed methods for extended seeing—satellite photos, radar, sonar—to illuminate topography too large or inaccessible to be observed by the eye. For Lin, such technology offers us another way of seeing landscape, and the conventions of mapping, such as topographic drawing, two- and three-dimensional modeling, and shifts in scale, are often made visible in her work. In her opinion, our relationship to landscape has been altered by our ability to view the earth from new vantage points, a shift in perspective that may also influence the character of landscape art in the twenty-first century.

In an essay on the subject of landscape in recent art, Rebecca Solnit makes the point that:

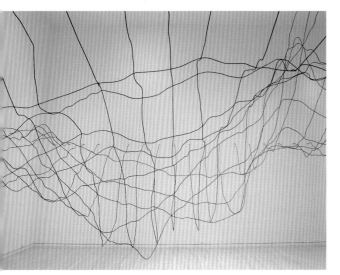

Water Line

> *In making landscape art, contemporary artists recognize landscape not as scenery but as the spaces and systems we inhabit, a system our own lives depend upon. In other words, there was no need to return to a landscape that had never been far from anything but our thoughts: it was the thoughts that had to change. The landscape is now thought of as ubiquitous—as the environment, a landscape that includes the microcosmic as well as the macrocosmic, economies as well as ecologies, the cultural as an extension of the natural, our bodies as natural systems that pattern our thoughts, and our thoughts as structured around metaphors drawn from nature.*[4]

She goes on to say:

> *Installation brings many of these issues inside, into environments that are responses to their sites and are sometimes metaphorical constructs of the world. The world here isn't represented in images of what is absent, but rather present in microcosm. Here, too, the viewer enters into the work, literally, geographically. The work may speak to the whole body, may have temperature, sensation underfoot, smell, sound and tactility, as well as sights. Installation could be described as an attempt to speak to the mind in the languages of the body: space, substance, systems, sensation.*[5]

Lin's installations and large-scale outdoor works ask for the viewer's full attention to the sensory experience of the work of art, whether the time it takes to walk an earthwork *(11 Minute Line)*, the sound and texture of falling water *(Civil Rights Memorial)*, or the constriction of a tight passageway *(Blue Lake Pass)*. The installations in *Systematic Landscapes* bring the experiential relationships of her exterior works inside. They are conceived in response to a contained space: *2 x 4 Landscape*, for example, began with the simple idea of walking up a steep hill indoors and approaching the ceiling.

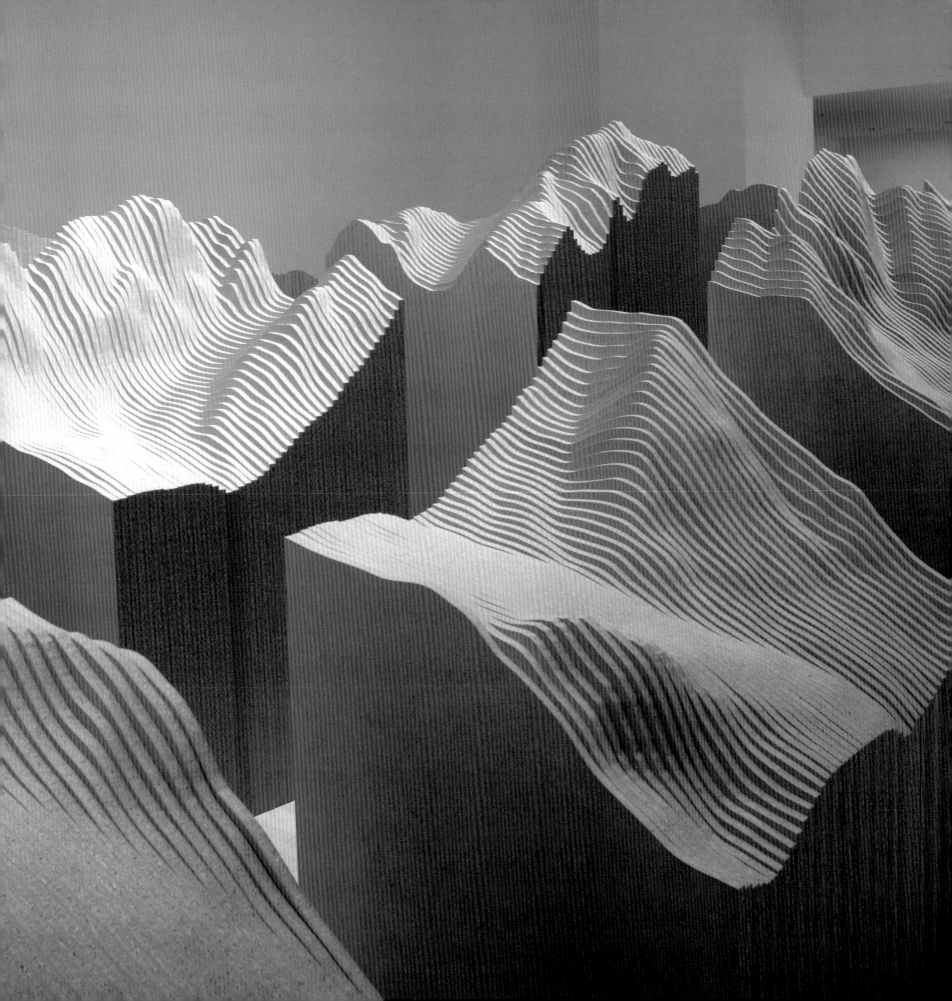

Making art about landscape in the twenty-first century must, to a degree, be tempered by the mounting evidence of the extent of our collective destruction of the world. The results of nature's being unhinged by the actions of mankind surround us, from the increasing ferocity and number of storms worldwide, to the shrinking of polar ice caps, to the advance of pollution in the world's river systems. These bleak facts tinge Lin's idealized landscapes with an environmental awareness suggesting the grim possibility that they may become monuments to the "end of nature."

In her book *Boundaries* Lin wrote about her interest in "the last memorial," a monument to the extinction of species on earth since the Industrial Revolution:

> *I would like to make one last memorial focusing on the extinction of species. Experts have called it the sixth-largest extinction since the beginning of this planet and the only extinction caused by the acts of one species. I envision a memorial not as a singular, static monument but one that would exist in many places at once, as well as one non-physical place, existing as a site on the Internet.*[6]

LANDSCAPES WITHIN ARCHITECTURE

Maya Lin's approach to making art and design is strongly intuitive:

> *I begin by imagining an artwork verbally. I try to describe in writing what the project is, what it is trying to do. I need to understand the artwork without giving it a specific materiality or solid form.*
>
> *I try not to find the form too soon. Instead, I try to think about it as an idea without a shape.*[7]

She continues:

> *My creative process balances analytic study, based very much on research, with, in the end, a purely intuited gesture.*[8]

Lin works with a vocabulary of form culled from her study of landscape, then by altering scale and materials, creates works that connect the ideal and the real. The large-scale installations in this exhibition, for example, are at once objects that represent aspects of actual landscape and environments to be experienced kinesthetically as sculptural landscape. The three installations, *2 x 4 Landscape*, *Blue Lake Pass*, and *Water Line*, all engage with the problem of bringing landscape into architecture by translating landscapes (two real and one imagined) into the materials of architecture while inviting viewers to move under, on, and through the works.

Each of the works is composed of a single material: two-by-four lumber, particleboard, or aluminum tubes. Each is configured to evoke a different aspect of landscape. Each went through the same process of design: creation of a three-dimensional model in Lin's studio, translation via

scanning or plotting into digital drawings, and finally, construction in full scale in Seattle. In short, they went from studio models made by hand to data printouts to large-scale works built again by hand, piece by piece, duplicates except in size of the original models in process and form.

Lin is fascinated with this challenge of bringing landscape into architectural space. Her 1998 exhibition *Topologies* included works such as the fourteen-ton glass installation *Avalanche* (1998) and *Topographic Landscape* (1997) that suggested landscape forms and forces. A permanent work at the American Express Client Services Center in Minneapolis, *the character of a hill, under glass* (2002) warps polished wood flooring into the contours of a hill punctuated by trees. Looking at it from a distance is a bit like seeing architecture in a fun-house mirror, with a curving floor instead of a flat one. Standing on it, one has the familiar experience of rolling hills: The writer Louis Menand described it as "like walking in the woods, where each step is registered differently in the body—a little higher or a little lower than the eye picks up from the terrain. You experienced the floor through your bones."[9]

Following *the character of a hill, under glass,* Lin wanted to explore further the possibility of bringing the idea of landscape to architectural space, an interest that led directly to *2 x 4 Landscape*. The installation is composed of more than fifty thousand vertical two-by-four boards placed in a configuration minutely detailed in models and drawings. Covering approximately twenty-four hundred square feet, it rises from a plane of short two-by-four segments to a hill ten feet tall. From some views the sculpture reads as a landform, and from others as a rising wave. It has an undeniable presence and feels like a fragment of landscape. Yet from afar, the truncated and irregular two-by-fours create a pixilated image, as if *2 x 4 Landscape* were again a model in the studio. The shape is both an imagined landscape and a real hill at the same time.

In her introductory statement for the exhibition, Lin describes *Blue Lake Pass* as

using a terrain chosen from the Rocky Mountain back range, creating a topographical sectioned landscape made from cut particleboard. The choice of terrain is something familiar and personal; our summer home is in Southwestern Colorado. By creating a sculpture that details that topology, applying a 3' × 3' grid to that terrain, and then pulling the terrain apart so that one can walk through the landscape, I wanted to shift one's perspective about the land. Allowing a viewpoint that is more geologic in character.

This work takes its name from one of the landmarks within the selected zone. The cubes that form the sculpture are made from vertical sheets of particleboard with the top edges cut to match a topographic line. Pulled apart into a grid, the topographic image is disjointed and the spaces between the cubes become narrow paths, or cuts, through the geography of the sculpture, exposing strata much like a highway carved through a mountain pass.

Water Line is a line drawing in space of a particular underwater location on the Mid-Atlantic Ridge, one that rises a few miles from the sea floor and is visible on the surface as Bouvet Island. Bouvet is one of the most remote islands in the world: The nearest land is Antarctica, roughly one thousand miles to the south. The island itself is tiny, four miles long by three miles wide,

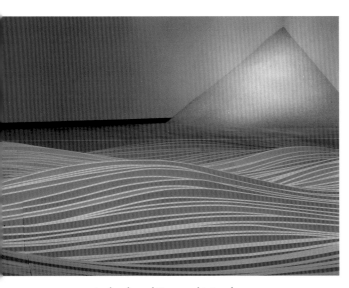

Avalanche and *Topographic Landscape*

but it is the crest of an immense and unseen mountain range. Working with scientists at Woods Hole Oceanographic Institute, Lin and members of her studio developed a topographic rendering of the seascape based on the research data obtained by scientific expeditions. The rendering was translated into architectural scale and fabricated from quarter-inch diameter aluminum tubes. During the installation, Lin subtly altered the configuration to emphasize the sense of a drawing in space rather than the rigid grid of a computer diagram, creating a looser line and a heightened feeling of inhabiting a topographic landscape.

Water Line emerges from the gallery walls and floats above the floor. The contours of the undersea mountain emerge clearly, and Bouvet Island can be envisioned as the tiniest fraction at the highest point of the work. The height of the balcony in the gallery approximates sea level and the viewer can imagine the transition from air to water to earth. This is a complex artwork: a three-dimensional re-creation of a topographical map, realized in a scale that affords viewers the opportunity to walk under and within its contours, and challenging their ability to imagine a largely invisible geography.

The unseen landscape is further explored in the *Bodies of Water* series, Lin's portraits of specific inland seas, those expanses of salt water that are partially or wholly landlocked. Here Lin takes up the representation of these immense volumes of water and shapes them from plywood layers. The top surface of each sculpture duplicates to scale the exact contour of the sea in question, while the vertical dimension, representing its depth, is exaggerated to create a more emphatic sculptural form. The resulting sculpture is balanced on its lowest—and deepest—point. The three bodies of water represented in this exhibition, the Caspian, Red, and Black Seas, are among the most endangered in the world, suffering from centuries of human encroachment and increasing industrial pollution. As Lin said in a recent lecture, "What we don't see, we pollute."

Accumulating materials, such as the stacked lumber in *2 x 4 Landscape,* is an approach Lin has used before in her work. Just as multiple pixels form an image on the screen, collected objects or fragments can create sculptural form. In *Groundswell* (1993, Wexner Center for the Arts), for example, she used mounds of glass, and in *Pin River–Columbia,* she uses tens of thousands of straight pins pushed into the wall. The pins create a flow of silver that is a shadow image of the Columbia River system, from the Canadian Rockies to the Pacific Ocean. A subtle environmental message is underscored by the slightly exaggerated swelling of the pins at eleven dam sites on the river.

Throughout her career Lin has made small-scale works in her studio, sometimes as sketches or models for larger works, but often as finished works. A number of smaller works in the exhibition, *Fractured Landscapes,* works from the *Atlas Landscape* series, and *Plaster Relief Landscapes,* evoke images of landscapes from altered building materials or found objects, mimicking nature's ongoing cycles of creation and destruction.

The *Fractured Landscapes* are rubbings made from the surface of a shattered sheet of plate glass. These works follow an earlier series of monoprints, *Flatlands,* that were "made by breaking an inked plate of tempered glass then running it through a press, forming a set of unique impressions that are reminiscent of a map or an ice floe pattern."[10] The new series, made with brown or

the character of a hill, under glass

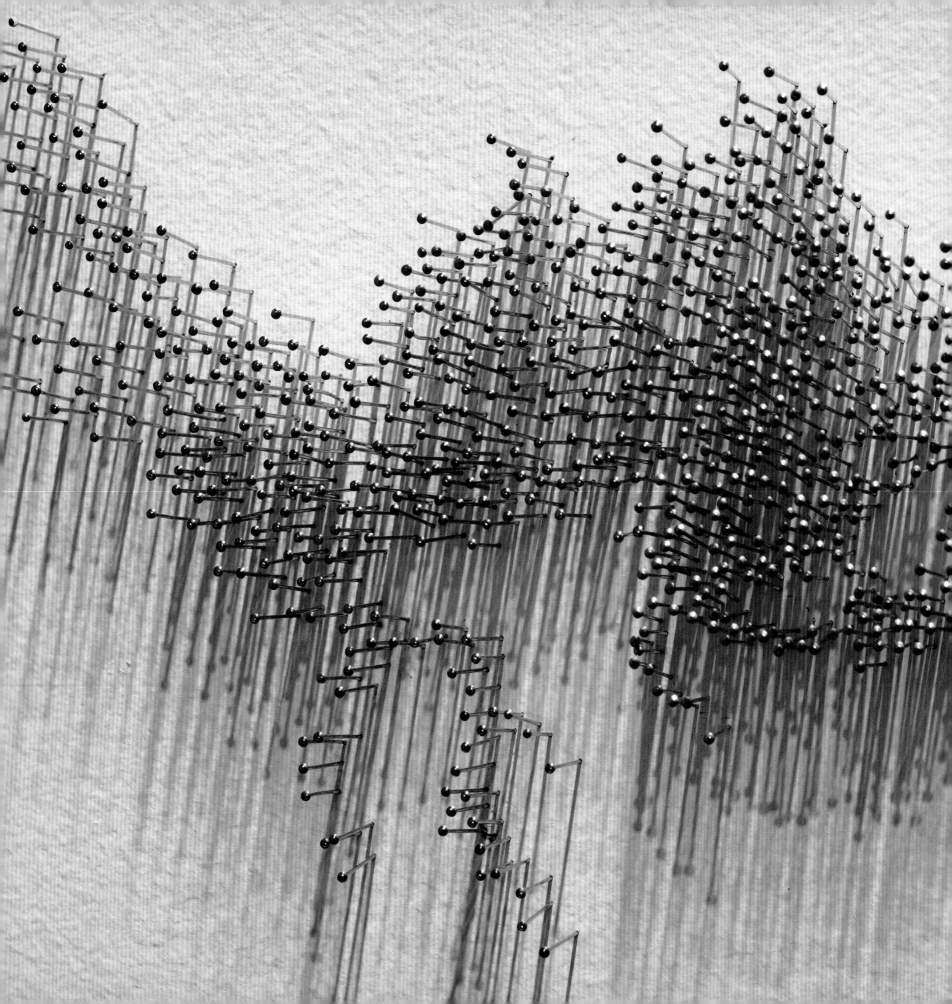

green pastel on paper, hovers between pure abstraction and evocative images of estuaries, mud-flats, islands, or river systems.

In the *Atlas Landscape* series, used books of maps become miniature landscapes, and layers of geographic images become strata. Lin carves down through the pages, one at a time, to create small canyons or erosions. A three-dimensional topography emerges from the layers of the atlas. In the *Plaster Relief Landscapes,* an existing wall surface is cut and a carved or modeled plaster relief is inserted. The works suggest views of landscape elements, such as ice sheets, river systems, or waves, seen at a great distance. The wall is patched with fresh plaster to make the connection seamless. The smooth plaster wall is transformed into an aerial view of a landscape, the plane of the wall interrupted irregularly as if sculpted by natural forces.

ART IN THE LANDSCAPE

Systematic Landscapes presents works of art that translate the gestalt of landscape into contained architectural space, extending Maya Lin's long-term interest in creating experiential, site-related environments. Lin is well known for her exterior works, beginning with the *Vietnam Veterans Memorial* in Washington, D.C. Much has been written about the memorial: the acrimonious debate around the selection of the design in 1981, the suitability of abstract sculpture as a vehicle for commemoration, Lin's unwavering commitment to her vision and, of course, the fact that the resulting work was a surprising (to her critics) and resounding success in the eyes of the public. So much has been discussed that it obscures the simple fact that this was the first public sculpture by an artist whose subsequent work returns again and again to characteristics present in it, namely a reductive approach to form, a highly attuned sensitivity to our relationship with landscape, and an intuitive approach to making art that turns feeling into form.

> *I had a simple impulse to cut into the earth.*
>
> *I imagined taking a knife and cutting into the earth, opening it up, an initial violence and pain that in time would heal. The grass would grow back, but the initial cut would remain a pure flat surface in the earth with a polished, mirrored surface, much like the surface on a geode when you cut it and polish the edge. The need for the names on the memorial would become the memorial; there was no need to embellish the design further. The people and their names would allow everyone to respond and remember.*
>
> *It would be an interface, between our world and the quieter, darker, more peaceful world beyond.*[11]

This powerful and evocative monument is nearly invisible on the National Mall. The memorial's slender arms of black marble do not rise above the plane of the ground to compete with the museums and monuments that line the two-mile-long park. From the sky, however, one would be able to see that the V of the Memorial derives its shape from a cartographic relationship to key landmarks, as its stone walls point to the Lincoln Memorial and the Washington Monument.

Approaching the *Vietnam Veterans Memorial,* the visitor descends slowly along a path. The Mall largely disappears from view, and the memorial draws you into its embrace. Then, as the reading of the fifty-eight thousand names builds, it delivers an emotional punch that is both powerful and unanticipated. This single work changed the course of American monument design by fusing the cool visual language of Modernism with the heat of memory and tragic loss.

Lin was notified of her winning entry in the design competition for the memorial the week before her graduation from Yale University. She was swept up in a maelstrom of controversy and thrust into a media spotlight so intense that it simply took over her life. She was spectacularly unprepared for the controversy and public scrutiny: Growing up in Athens, Ohio, she and her brother, Tan, were the children of academics and had been largely insulated from the racial and cultural divisions of urban America.

Lin's parents had fled, separately, from China in the late 1940s as the Communist government strengthened its grip on the country. Her father, Henry, studied ceramics at the University

Left to right:

Serpent Mound, Ohio.

James Turrell, *Roden Crater (survey frame 5752),* 1982. Color type R print, 36½ × 36½ in. (92.7 × 92.7 cm) exposed image size. Henry Art Gallery, Joseph and Elaine Monsen Photography Collection, gift of Joseph and Elaine Monsen and The Boeing Company.

Robert Smithson, *A Nonsite (Franklin, New Jersey),* 1963. Painted wood bins, limestone, and gelatin silver prints and typescript on paper with graphite and transfer letters mounted on mat board; 16½ × 82¼ × 103 in. © Estate of Robert Smithson/Licensed by VAGA, New York, NY. Image courtesy James Cohan Gallery, New York.

Michael Heizer, *Adjacent, Against, Upon,* 1977. Concrete and granite, 9 × 25 × 130 ft. Seattle City Light 1% for Art.

Richard Long, *Puget Sound Driftwood Circle,* 1996. Driftwood, 276 in. diam. Henry Art Gallery, purchased with funds from Rebecca and Alexander Stewart; Bill and Ruth True; Mrs. Carol Wright; H.S. Wright III and Kate Janeway; Kayla Skinner Fund; and partial gift of the artist and Donald Young Gallery.

of Washington, where he met and married Julia. The family moved to Ohio University in Athens, and Henry became Dean of Fine Arts and Julia, a professor of literature. Lin has fond memories of growing up in a Midwestern small town and remembers her parents' efforts to assimilate their two children into American culture.

Among Lin's childhood memories are the pleasure of exploring the ancient (ca. A.D. 1000–1500) Serpent Mound of central Ohio, one of the largest Native American effigy mounds in the United States, and countless hours spent in her father's ceramic studio making objects in clay. Lin has a strong sense of an Eastern design influence in her work, even though her upbringing emphasized American, rather than Chinese, language and culture. She attributes this sensibility to the influence of her father, whose craftsmanship and interest in Asian design and Modernist style were combined in the dishes and furniture of the household. As an adult, Lin traveled to her father's childhood home in Fukien province, China. There she discovered

that her father had grown up in a house designed in a Japanese style, the result of his mother's great interest in the simple forms of traditional Japanese architecture. Lin was inspired by this bit of family history, as she had always felt a closer relationship in her own work to the spare forms and landscape relationships of Japanese design than to the more elaborate Chinese style.

I probably spent the first twenty years of my life wanting to be as American as possible. Through my 20s and into my 30s, I began to become aware of how so much of my art, and architecture, has a decidedly Eastern character. I think it is only in the last decade that I have understood how much I am a balance and a mix.[12]

Just how much she is a balance and a mix is evident in looking at the generation of American and European land artists that preceded her, whose permanent and temporary projects provided

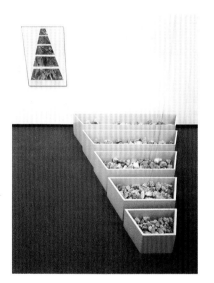 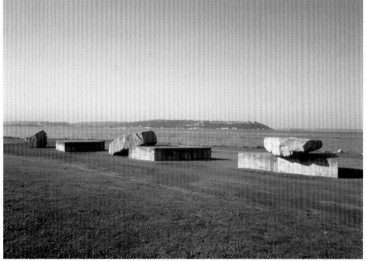 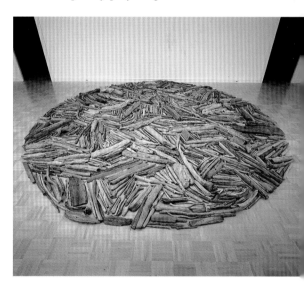

a new vocabulary of sculptural form in and on the landscape. Or, perhaps "renewed" vocabulary might be an equally appropriate term, as many of these artists were influenced by ancient earthworks and observatories across the world, just as Maya Lin was drawn to the Serpent Mound in Ohio.

In the 1960s and 1970s, American artists such as Robert Smithson, Michael Heizer, Nancy Holt, James Turrell, and Walter de Maria made their mark in art history by using the earth as a canvas for works that explored issues of large scale and the characteristics of site; natural processes, such as gravity or entropy; or natural phenomena—lightning for de Maria at *The Lightning Field*, celestial motion for Turrell at Roden Crater. The isolation and vastness of the American West meant that there was ample room and opportunity for artists to experiment with the fundamentals of sculpture—cutting, removing, and adding—and drawing—lines cut and scratched into the earth—on a truly remarkable scale.

In contrast, European artists such as Richard Long, Andy Goldsworthy, and Wolfgang Laib moved from the studio into a natural world that was largely domesticated. The pockets of forests, glades, and other relatively untouched landscapes left by centuries of cultivation were not well suited to manipulation by artists on a grand scale. Moving into the landscape, these artists operated less as builders of places and objects, and more as explorers who returned from solitary walks with evidence or documentation of the fragile beauty of nature. Long's stone markers arranged in the course of a walk through the landscape, Goldsworthy's gathered ice and leaf sculptures in a field, or Laib's laborious collecting of pollen to form fields of pure color all evoked a sense of powerful connection to nature and acute awareness of the temporal quality of human interaction in the landscape. Unlike the Americans, whose work favored materiality and intervention, the work of the Europeans had a strong poetic, even Romantic, emphasis.

Maya Lin's approach to art combines aspects of the Americans' focus on material and site and the Europeans' Romantic sensibility with an Asian outlook that emphasizes awareness and connection to nature. Lin's translations of natural formations have parallels, in fact, in the invented landscapes within Zen gardens known as *Kansho-niwa*. These classic contemplation gardens of the Muromachi period were built within walled compounds and reflected an austere aesthetic and an allegorical approach to depicting the essential forms of nature. These were gardens for the mind: "meant exclusively for viewing from the nearby hall . . . the viewer does not physically enter the garden but rather explores it mentally."[13] In their contrast of the real and the ideal (the shape of hills or waves distilled to an essential form but translated to another material, for example), Lin's *The Wave Field* and *2 x 4 Landscape* may have more in common with the philosophical underpinnings of Zen gardens, such as Ryoanji in Kyoto, with its raked-sand sea and stone mountains, than with, say, Michael Heizer's *Adjacent, Against, Upon*, with its emphasis on the nature of material and process. Lin's work reflects the two streams of influences, West and East, that make up her hybrid cultural background.

> *I have become increasingly conscious of how my work balances and combines aspects of my Eastern and Western heritages. I see my work as a voice that is of both cultures, profoundly tied to my Asian American identity. . . . This Asian influence has led to a body of work that is experiential and educational in nature; they are passages to an awareness, to what my mother would describe in Taoism as "the Way": an introspective and personal searching.*[14]

During the twenty-seven years since the unveiling of the *Vietnam Veterans Memorial*, Maya Lin's deep involvement with history and nature has led to sculptures, monuments, landscape design, and buildings, a spectrum of activity that reflects the breadth of her capabilities and her uncommon ability to apply her eye and hand to opportunities as disparate as an earthwork in Sweden; a library for the Children's Defense Fund in Clinton, Tennessee; and a seven-site project in Washington and Oregon along the Columbia River, which commemorates the journey of Lewis and Clark while acknowledging the Native American tribes along the path

Wolfgang Laib, *Pollen from Hazelnut*, 1995–96.
Hazelnut pollen, 70⅞ × 74¾ in. (installation size). Henry Art Gallery, gift of William and Ruth True with additional funds from Rebecca and Alexander Stewart and the Henry Gallery Association Collections Committee.

of contact and the flora and fauna that have fallen by the wayside since the Corps of Discovery passed by.

But always, her work operates from a humanistic and philosophical footing. The breadth of her work cuts across disciplines, combining a poetic sensibility with a scholar's drive to understand the world. Her monuments take on issues of history and memory using language as a guiding source for both meaning and form. Her recent installations, sculptures, and drawings explore our relationship to the larger world, particularly our ability to see the intertwining of landscapes and ecological systems. The works focus attention on our ability to understand our place in the world and, equally, on our capacity for creative or destructive interaction.

Lin is an artist whose visionary production creates emotionally resonant art, monuments, and architecture from simple forms and materials. Her creative instincts carry her across the borders that traditionally separate art and design. For much of her career, this cross-disciplinary activity set her apart from other artists, but in recent years a number of contemporary artists, such as Andrea Zittel, Roy McMakin, and Jorge Pardo, have also discovered the creative opportunity that exists at the boundaries. At midcareer, Maya Lin has produced a profound and influential body of work that gives poetic form to our memories, reminds us of our relationship to the natural world, and heightens our awareness of the essential linkage between feeling and thought. As we face an uncertain future her work will remain timely, and we can look forward to new works that help us find "the place where opposites meet."

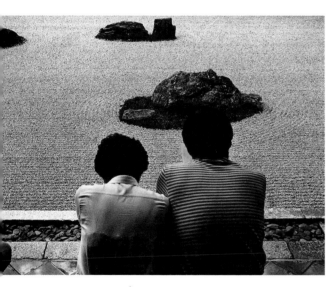

Ryoanji Garden, Kyoto

1. Maya Lin, *Boundaries* (New York: Simon & Schuster, 2000), 2:07.

2. Yi-Fu Tuan, *Space and Place: The Perspective of Experience* (Minneapolis: University of Minnesota Press, 1977), 10.

3. *Boundaries*, 0:01–0:05.

4. Rebecca Solnit, *As Eve Said to the Serpent* (Athens: University of Georgia Press, 2001), 47.

5. Solnit, 61.

6. *Boundaries*, 12:03.

7. *Boundaries*, 3:05.

8. *Boundaries*, 3:09.

9. Louis Menand, "The Reluctant Memorialist," *The New Yorker*, July 8, 2002, 65.

10. *Boundaries*, 8:02.

11. *Boundaries*, 4:10.

12. Academy of Achievement, academy honoree interview, June 2000.

13. Marc P. Keane, *Japanese Garden Design* (Rutland, Vermont and Tokyo: Charles E. Tuttle Publishing Co. Inc., 1996), 59.

14. *Boundaries*, 5:03.

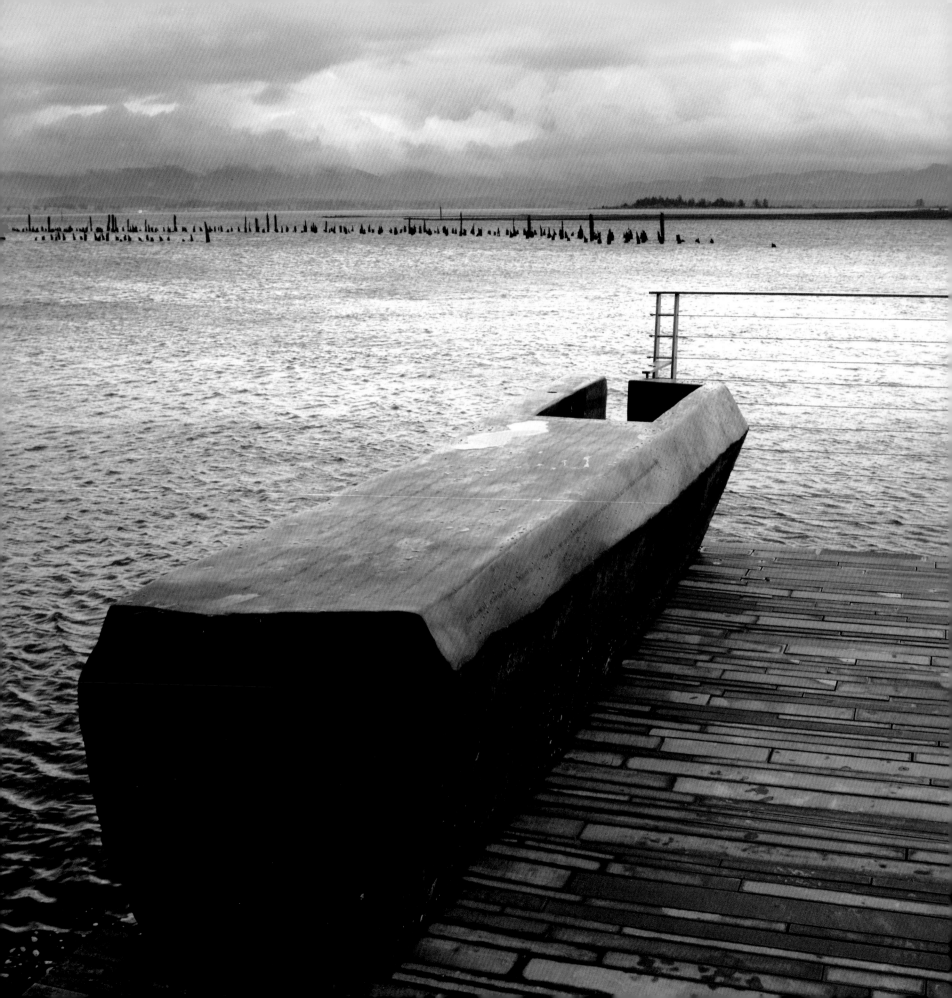

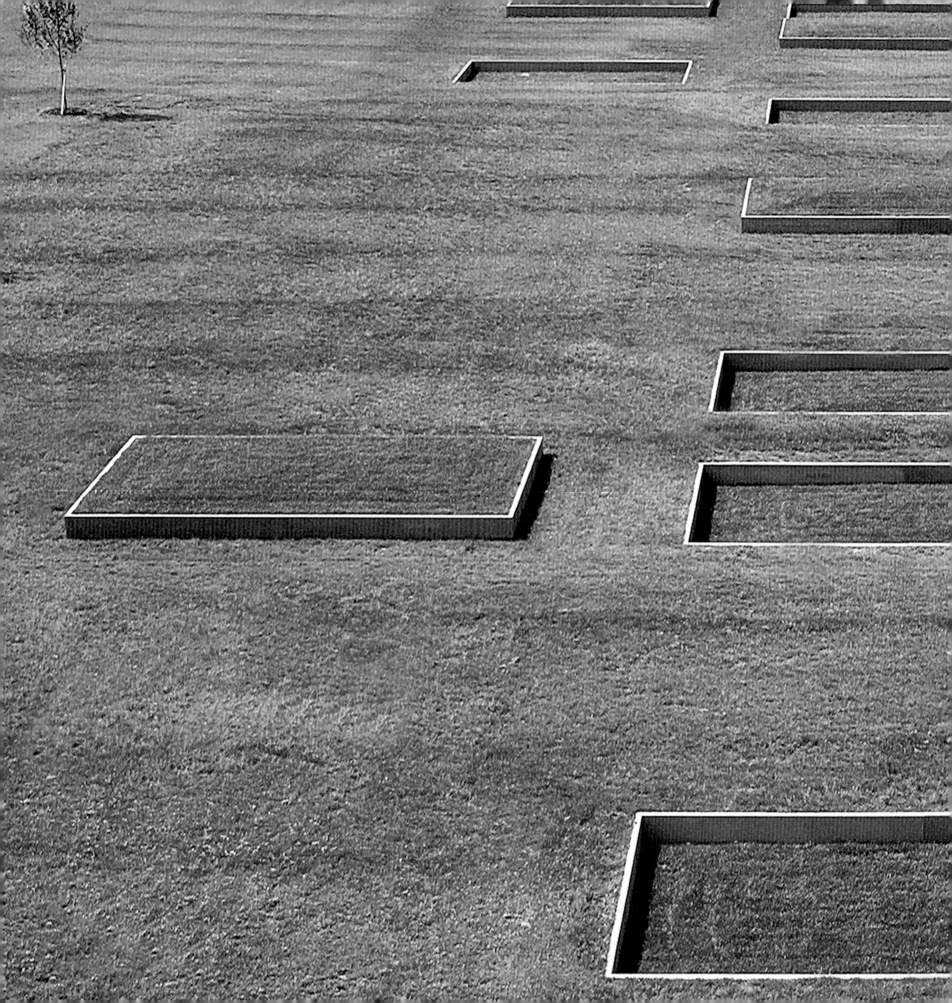

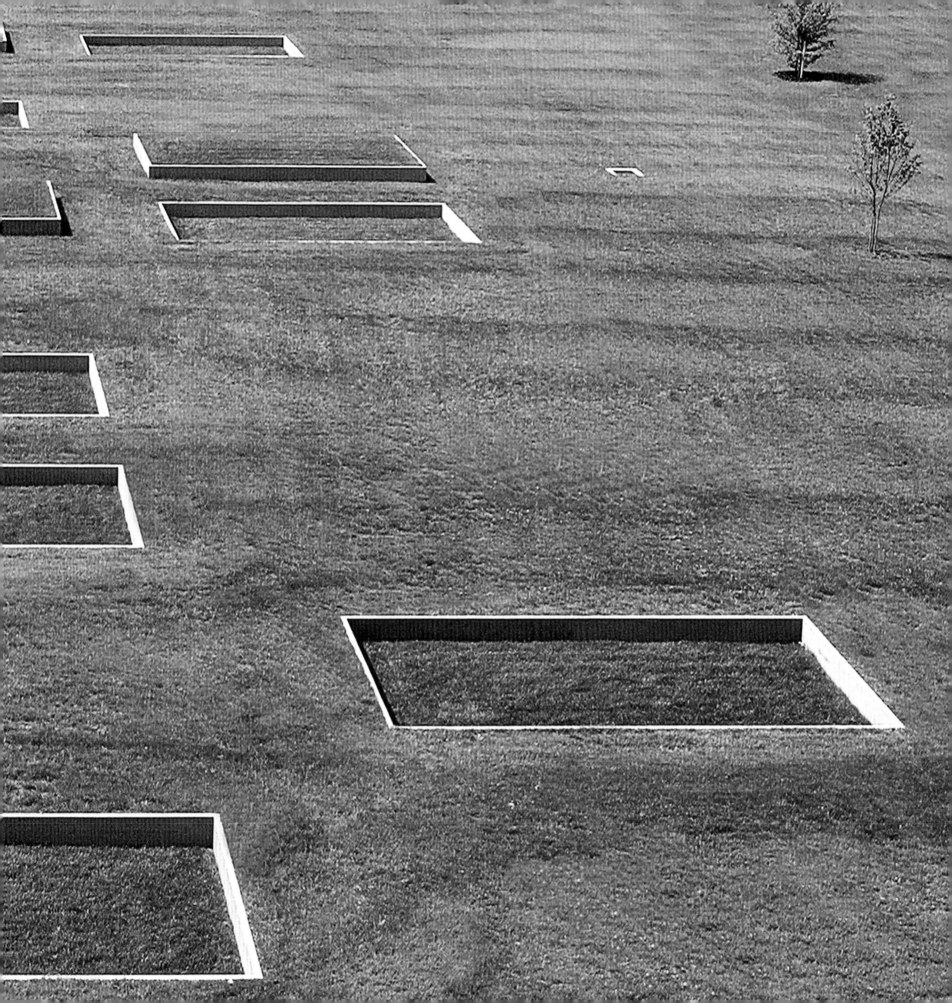

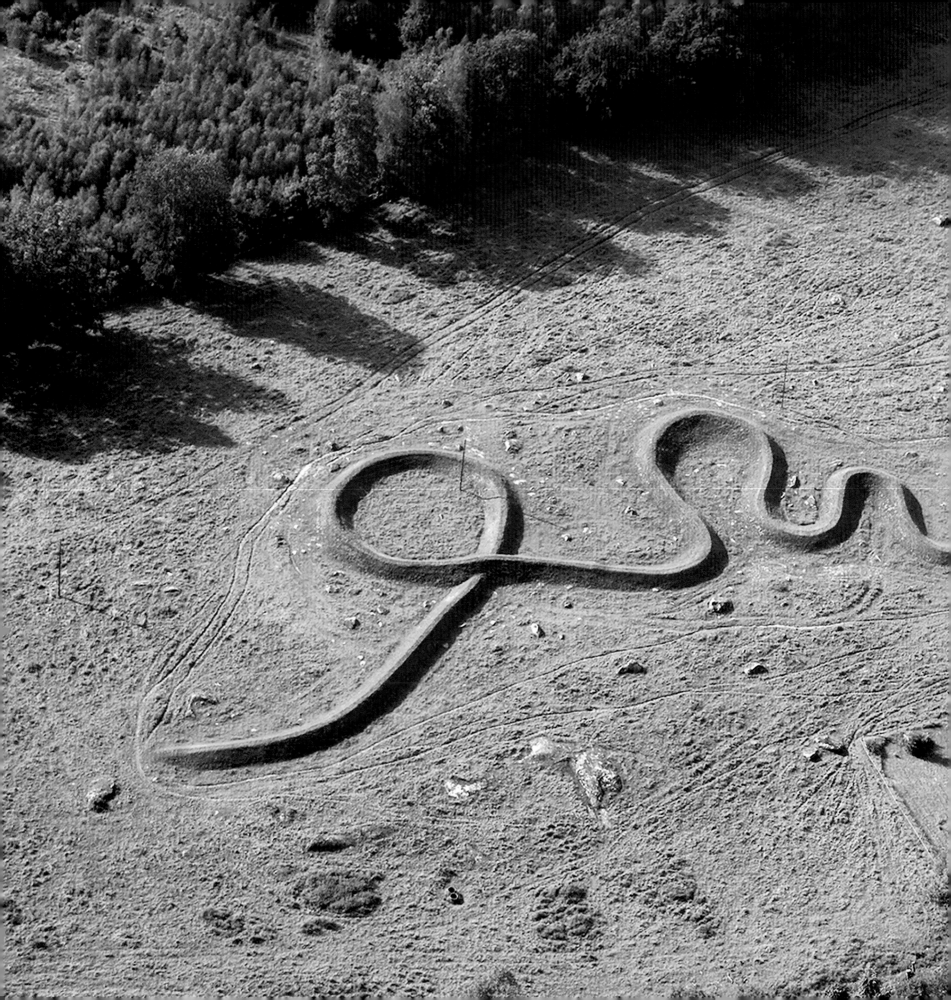

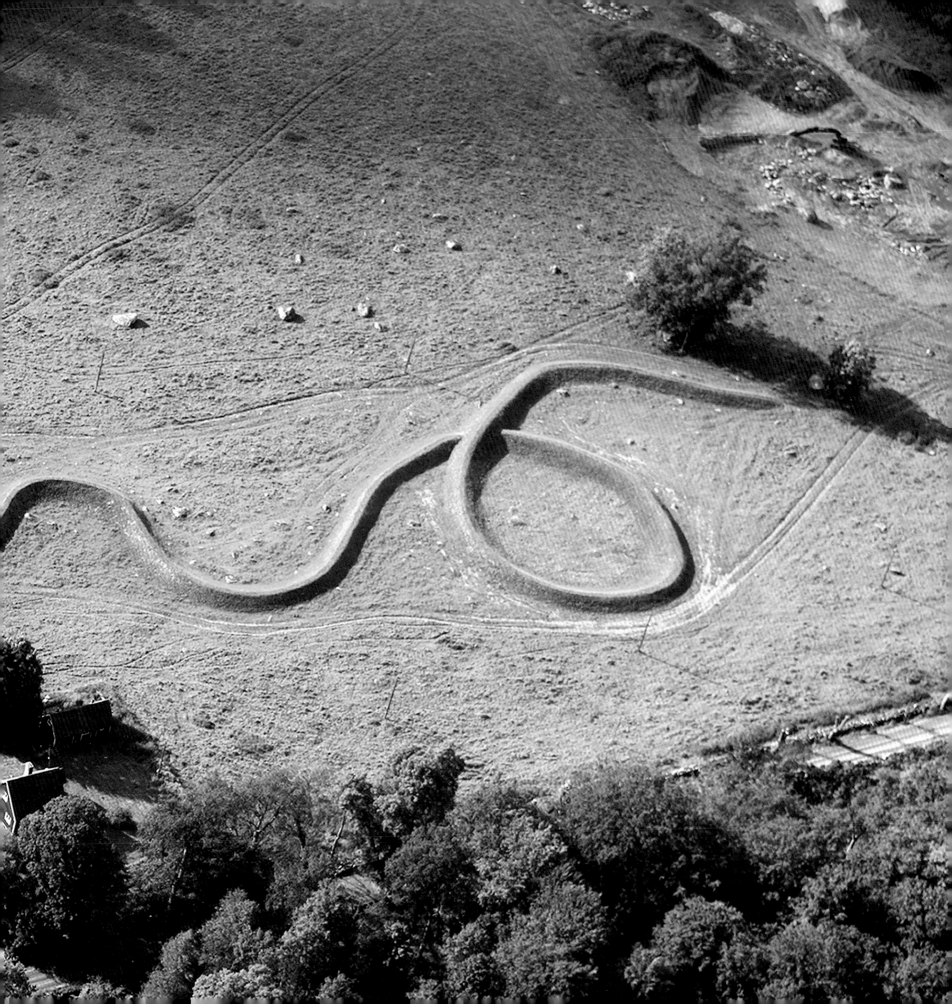

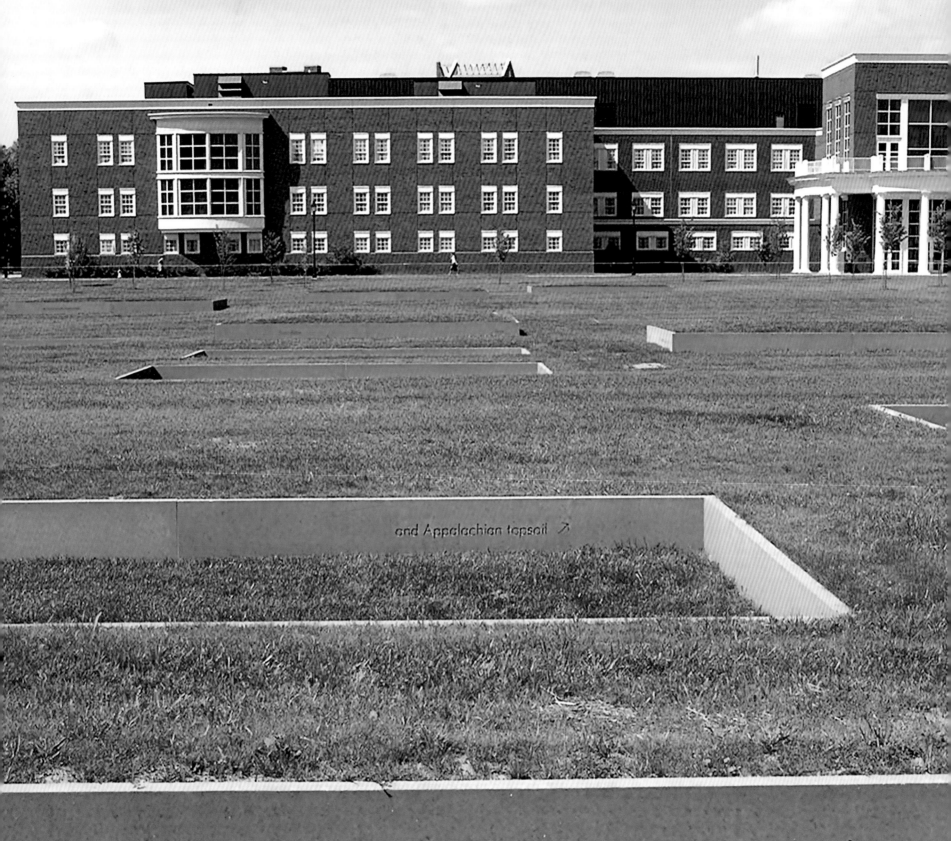

and Appalachian topsoil ↗

The map you are reading is a kind of topographic landscape.

Hidden in Plain View:
The Land Art of Maya Lin

John Beardsley

More public a figure than Maya Lin could be scarcely imagined in the world of contemporary art. There are artists and designers more celebrated than she, but few have stood so resolutely in the crosshairs of cultural debate. Initially thrust into the line of fire in 1981 when, as a senior at Yale, she won a national competition to design the *Vietnam Veterans Memorial* in Washington, D.C., she was forced to defend her elegant design—two black granite walls sunk into the sloping ground—against charges that it was unpatriotic and antiwar. She also had to withstand more subtle suspicions that an Asian American and a woman had no business designing a war memorial, much less a memorial to those who died in an Asian war.[1] To greater and lesser degrees, Lin has stayed in the limelight ever since. She has designed other public monuments, notably the *Civil Rights Memorial* in Montgomery, Alabama (1989), and *The Women's Table* on the campus of Yale University (1993). She has received high-profile architectural commissions, including the interior for the Museum for African Art in New York (1993) and the Langston Hughes Library for the Children's Defense Fund at the Haley Farm in Clinton, Tennessee (1999). She was also the subject of a widely distributed and highly lauded film by Freida Lee Mock, *Maya Lin: A Strong, Clear Vision*, which won the Academy Award for best documentary in 1995. More recently, she was a finalist for the design of the Olympic torch for the 2008 summer games in Beijing. In a very visible way, she has been a polymath in an era of specialization, a hybridizer at a time when political and cultural differences seem to be hardening into open hostility.

Lin conveys a sense at times that all this visibility sits rather uncomfortably with her. She acknowledges in her book *Boundaries* that she has only recently been able to write about and thus relive some of the debate surrounding the design of her most public project: "It's taken me years to be able to discuss the making of the *Vietnam Veterans Memorial*, partly because I needed to move past it and partly because I had forgotten the process of getting it built. I would not discuss the controversy surrounding its construction and it wasn't until I saw the documentary, *Maya Lin: A Strong Clear Vision*, that I was able to remember that time in my life." But she seems also to experience a more vague and generalized discomfort from living a border life: "I feel I exist on the boundaries. Somewhere between science and art, art and architecture, public and private, east and west." Her writing betrays some unease with this situation: "I am always trying to find a balance between these opposing forces, finding the place where opposites meet . . . existing not on either side but on the line that divides. . . ."[2] This discomfort shouldn't surprise us: Frontiers are inherently challenging places. In ecology, the boundary between plant communities is described as an ecotone, from the Greek word *tonos*, meaning tension. But as difficult as these frontiers are, they are also enormously fertile, characterized by broad adaptability and diversity of species.

Maya Lin's ecotone is equally productive and diverse, though full of hidden corners. While she has played out her professional life largely in public, there are significant aspects of her work that remain comparatively unknown. She has been quite prolific as a sculptor, both indoors and out, working in wood, stone, and glass. She has created installations that combine sculpture and architecture, such as *10 Degrees North* at the headquarters of the Rockefeller Foundation in

New York or *the character of a hill, under glass* at the American Express Client Services Center in Minneapolis. She has worked in the manner of a landscape architect, creating an arts plaza at the University of California at Irvine (2005) and *Ecliptic,* a public space with an amphitheater and water and mist fountains in Grand Rapids, Michigan (2001). She has also made some remarkable freehand drawings and rubbings of shattered glass. But among her least known or appreciated works are her recent earth sculptures: *11 Minute Line,* a sixteen-hundred-foot-long serpentine mound for the Wanås Foundation in Sweden (2004); *Input,* a field of raised and recessed rectangular beds of soil and grass that irregularly punctuate a three-and-a-half-acre lawn on the campus of Ohio University in Athens (2004); and *Flutter,* grassy waves that texture the landscape in front of the Wilkie D. Ferguson, Jr., Federal Courthouse in Miami, Florida (2005). These new projects add to an already significant group of earlier landscapes, including *The Wave Field,* ten thousand square feet of undulating turf at the University of Michigan (1995), and *Groundswell,* mounds of mixed clear and green glass in unused courtyard and rooftop spaces at the Wexner Center on the campus of Ohio State University in Columbus (1993). Others are still to come, including a forty-thousand-square-foot installation at the Storm King Art Center in Mountainville, New York. Taken together, these projects confirm her standing as one of the most ambitious and accomplished of contemporary environmental artists.

What holds true in Lin's professional life is also true of her landscape work itself: It is at once highly visible and hidden. On a visual level, it can seem self-evident, manifesting a formal lucidity, even simplicity, that masks conceptual, psychological, and perceptual complexity. "All my work," she explains, "starts with the impulse to feel something, to experience something." As she confirmed in *Boundaries,* she strives "to make people aware of their surroundings, not just the physical world but also the psychological world we live in."[3] Her subject might be shared history, individual recollections, or bodily experience, but in all cases, her goal is to "shift perception ever so slightly," to draw attention to the ordinary—"to what we think we already know." While deploying an explicit language of form, her deeper, more subtle aim is to foster contemplation in the landscape—of time, memory, or passage.

Lin's fascination with perceptual and temporal experience has been apparent from the outset. She describes the descent into the space of the *Vietnam Veterans Memorial,* for example, as a "passage to an awareness about loss."[4] A similar intent is behind some of her more recent projects, including *11 Minute Line.* The title of this piece is a clue to its purpose: to focus attention on the experience of walking it from one end to the other, an experience that consumes an average of eleven minutes. Like the *Vietnam Veterans Memorial,* this project changes your perspective by changing your elevation—in this instance, by raising you above the ground. *Input* is equally addressed to the interplay of temporal and spatial experience. The piece is understood through exploration, an activity that is reinforced by inscriptions found on the inside of some of the rectangles' concrete liners. The text was composed by the artist and her brother, Tan Lin, a writer and poet; the words convey their memories of Ohio University and of Athens, where they grew up. The text is scattered throughout the piece; some of it is contiguous, some interrupted. It requires a concentrated effort to put it all together.

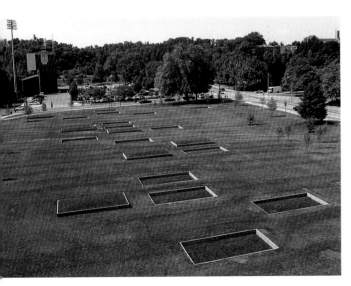

Input

In all these projects, Lin's focus is on the qualities of peripatetic perception: the way large-scale art in the landscape can focus attention on the experience of a body in motion through space over time. Time and space are understood in concert: Time becomes spatial and space is understood as temporal. Much recent large-scale sculpture, notably that of Richard Serra, has been analyzed for its peripatetic qualities.[5] Lin's work certainly shows affinities with Serra's: The *Vietnam Veterans Memorial*, for instance, recalls his work from the early 1970s—sculptures such as *Shift* in Ontario or *Spin Out: For Robert Smithson* at the Kröller-Müller Museum in the Netherlands, both of which use elongated, rectilinear elements to intensify the experience of sloping topographies. In a similar way, the *Vietnam Veterans Memorial* employs a reductive language of planar geometry; like Serra's work, it also reveals shifting alignments with the horizon and impels passage through space over time.

But Lin's relationship to Serra's sculpture is complicated and, at least initially, indirect: She reports that she was unaware of his work when she designed the *Vietnam Veterans Memorial*—she would not encounter it until some years later when a graduate student at Yale.[6] Instead, she says, she first developed an interest in the perceptual and psychological experience of space through her undergraduate studies in architecture—particularly Vincent Scully's history lectures —and her readings in aesthetic theory, including Junichiro Tanizaki's *In Praise of Shadows*, Gaston Bachelard's *Poetics of Space*, and Steen Eiler Rasmussen's *Experiencing Architecture*. Moreover, she points out that her approach to the *Vietnam Veterans Memorial* was "to cut away the earth, giving it a skin, extracting space" rather than adding form to the landscape as she perceives Serra does. Instead of deriving the *Vietnam Veterans Memorial* from Serra's example, in other words, Lin arrived at an interest in lived experience from a different point of departure, while expressing it in a similar language.

Lin's work, like Serra's before it, confirms a change in recent sculpture that the historian and critic Hal Foster describes as "a partial shift in focus from object to subject, from ontological questions (of the essence of a medium) to phenomenological conditions (of a particular body in a particular space as the ground of art)."[7] Lin is only peripherally aware of phenomenological interpretations of contemporary sculpture, which owe something to the French philosopher Maurice Merleau-Ponty's emphasis on the body in perception and action and to the German phenomenologist Edmund Husserl's interest in time consciousness and its relation to the identity of the self. Although she had no direct exposure to the ideas of phenomenology, the way she talks about her eventual experience with Serra's art suggests that she absorbed these ideas, as she says, "through the skin." She describes, for instance, her first encounter with Serra's *St. Johns Rotary Arc*, an elongated curved steel sculpture installed for a time near the entrance to the Holland Tunnel in New York, as "unbelievable." It was one of just a few experiences that she says "changed my ideas about art"; seeing Smithson's *Nonsite* sculptures was another. She encountered *Rotary Arc* for the first time at night; as she walked along it, she recalls, "I kept thinking about the curve of the earth, about how you don't know what's ahead of you until you turn the corner." This sense that sculpture can inspire motion and provoke exploration has become a consistent feature of Lin's subsequent landscape work.

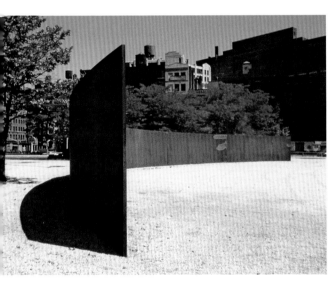

Richard Serra, *St. Johns Rotary Arc*, 1975/1980.
© 2006 Richard Serra/Artists Rights Society (ARS), New York.

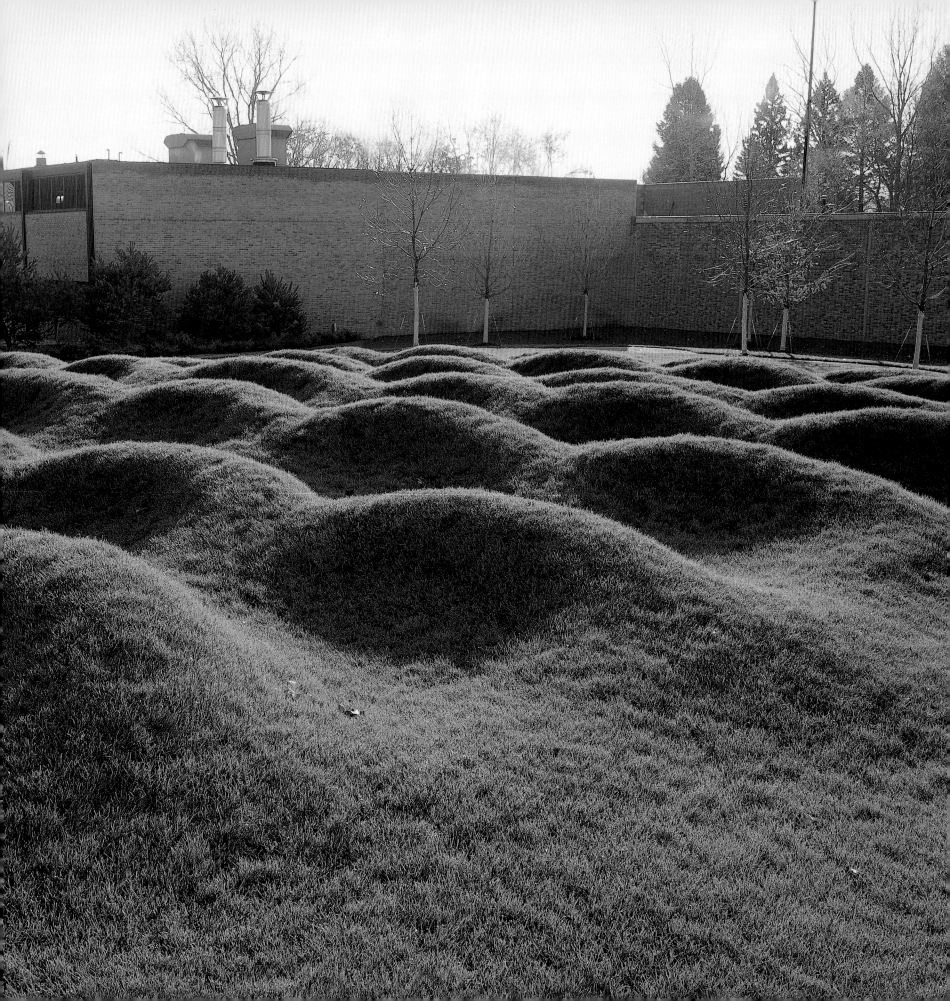

As much as Lin's work might evoke Serra's example, it also suggests affinities with Japanese conceptions of space-time signified by the word *ma*. The importance of *ma* in Japanese aesthetics was affirmed by the architect Arata Isozaki in a 1978 exhibition at the Musée des Arts Décoratifs in Paris, which is when the notion began to gain traction in the West. In both the exhibition and its accompanying publications, Isozaki used the ancient Chinese character *ma* to describe how he thought space and time were intertwined in Japanese culture. In spatial terms, he suggested, *ma* is "the natural distance between two or more things existing in a continuity." In temporal terms, *ma* is "the natural pause or interval between two or more phenomena occurring continuously."[8] Neither space nor time in this conception is fixed; neither exists without the other. Space is experienced through time; time is measured by movement through space.

In Japanese landscape traditions, one of the most common devices for heightening an awareness of the relationship between space and time is the stepping stone. Stones establish intervals; they make a person more conscious of physical and perceptual activity. They are a common feature in gardens associated with the tea ceremony, especially those of the hermitage type. The Japanese garden historian Teiji Itoh distinguishes two principal forms of tea gardens: those with a veranda overlooking an enclosed courtyard intended for static viewing *(waki no tsubonouchi)* and those reached by a pathway or passage and meant to evoke a rustic retreat *(uchi roji)*. Both these types are found at Koto-in, for example, a sub-temple of Daitoku-ji in Kyoto built during the Momoyama period (ca. 1600), where there is an enclosed garden meant to be viewed from a tearoom and an elaborate garden path with stepping stones, gates, lanterns, and water basins that leads to a hermitage-style tea house. As Itoh describes the differences between these two types, "the *tsubonouchi* gave importance to a tranquil scenic or spatial composition to be viewed from a static position, while the *roji*, designed for carrying out an essential preliminary ritual of the tea ceremony, laid major stress on providing the guests with a series of spatial experiences as they walked through it." Itoh notes that these experiences were both physical and psychological in character, meant to produce a kind of mindfulness that would prepare guests for the tea ceremony. "The *tsubonouchi* functioned on the premise that the guests would be sitting still, the *roji* on the premise that they would be in motion. Indeed, one of the most important aspects of the *roji* is the careful and deliberate attention with which it is designed to produce psychological changes in the people who walk through it."[9]

There are devices other than stepping stones that also produce a heightened awareness of motion in Japanese gardens. Movement is often indirect; it is frequently interrupted with places for pauses. At the entrance to Koto-in, for example, there are several right-angle turns in the approach walk, causing momentary pauses and reorientations. Stepping up and stepping down are other devices to establish interval and spacing. At the same temple, a gated threshold marks the transit from one realm to another: Stepping over the threshold brings an awareness of passing from the everyday to the consecrated or otherwise differentiated environment. In all, Japanese temple gardens were among the first in the world to be specifically conceptualized for walking; *ma* provides an intellectual framework for understanding their spatial and temporal character.

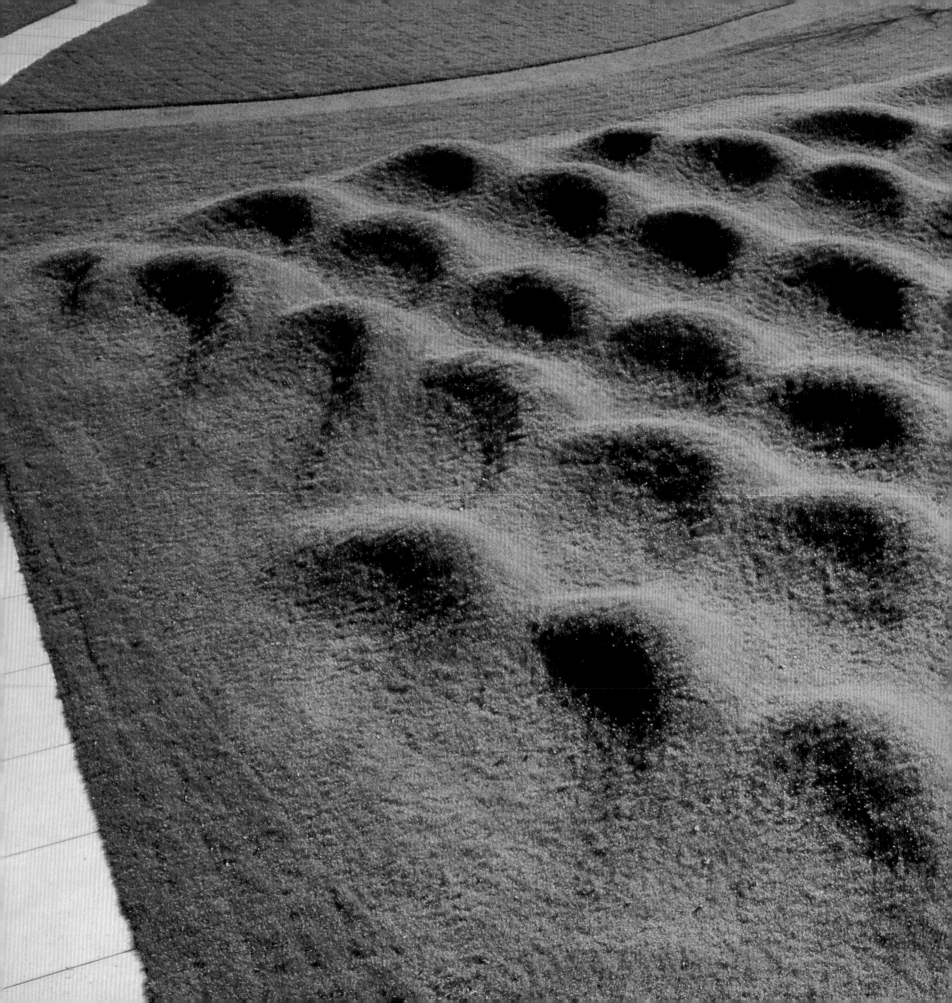

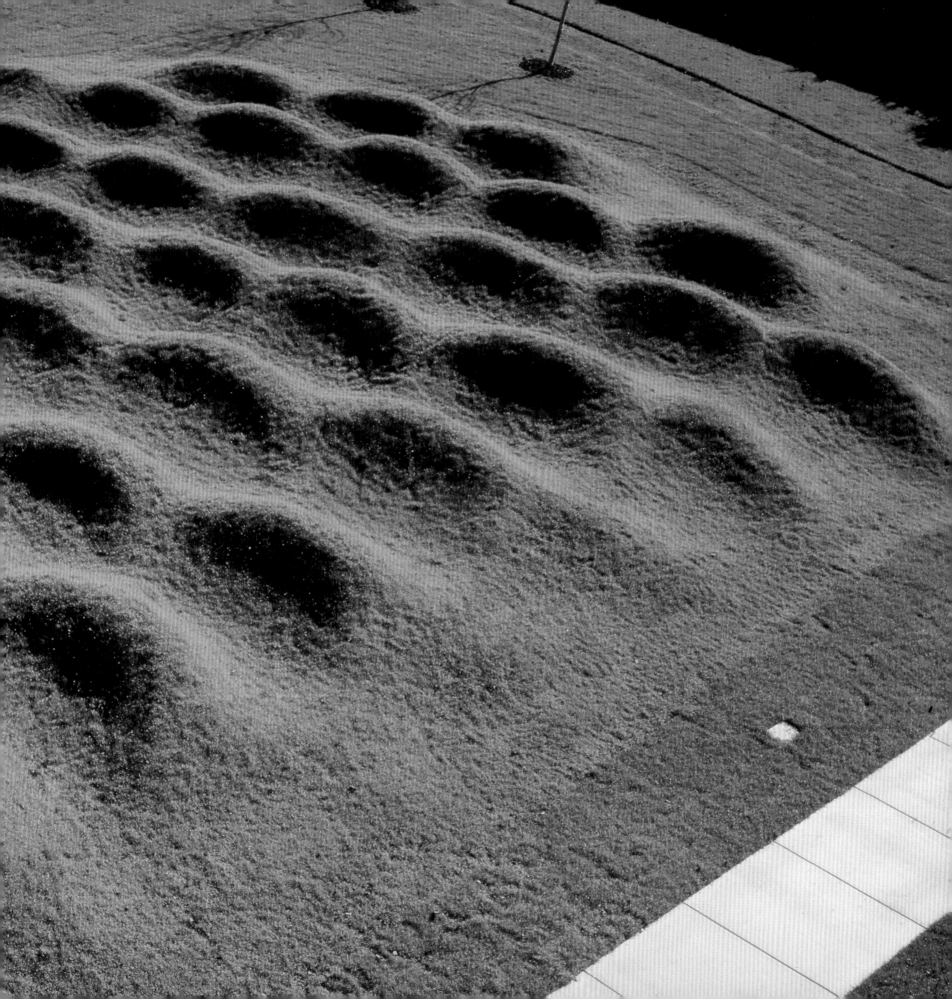

Again, Lin seems to have absorbed the lessons of Japanese landscape aesthetics through the skin: "I wasn't trained in the fine arts," she admits. She was initially drawn to Japanese architecture as a student, noting the "simplicity and craftsmanship" of courtyard houses, gardens, and temples. She received direct exposure to this work when, as a graduate student, she spent a summer in Japan; she interned for six weeks in the office of the architect Fumihiko Maki in Tokyo and visited temples and gardens in Kyoto. Her landscape work reveals some formal debts to Japanese precedents: She says the water tables of the *Civil Rights Memorial* and *The Women's Table,* for instance, are inspired by the hollowed-stone basins used for ritual hand washing in temple gardens. *Groundswell,* with its carefully shaped piles of glass, evokes the sculpted sand or raked gravel of *kare-sansui* or dry-stone gardens in Kyoto: the sand cone at Ginkaku-ji, for example, or the symmetrical mounds in raked gravel at Daisen-in, another sub-temple of Daitoku-ji.

In a larger sense, Lin was schooled in Asian aesthetics. Both her parents were born in China; both were artists: her father a ceramicist, her mother a poet. Growing up with the art and furniture made by her father, she absorbed the aesthetic of simplicity and careful craftsmanship she later learned to admire in Japanese design. She didn't discover much about her parents' pasts until she was an adult, when she made a trip to China with her family in 1985. There, she was surprised to learn that her father had grown up in a Japanese-style courtyard house built by his father in Fukien province; her grandfather was also a collector of Chinese ceramics, which had a pronounced impact on her father. In her own work, Lin recognizes a distinctly Asian influence in choosing to create "meditative spaces that seem almost too subtle in their design, yet have a quiet teaching method or approach."[10] But arguably her most potent connection to Asian or—more specifically—Japanese aesthetics comes in her attention to the qualities of perception-in-motion and its capacity to provoke psychological changes. As Mark Taylor has noted, Japanese ideas intersect in Serra's work with those of phenomenology; the same is true for Lin's.[11] Her exposure to Japanese garden art is hybridized with her experience of the discourse surrounding contemporary American sculpture.

Those familiar with recent land art might recognize additional affinities between Lin's work and that of other artists. The form of *11 Minute Line*—which seems to have been generated by dropping a string and recording its accidental shape—recalls some of Michael Heizer's earliest land art, particularly the *Nine Nevada Depressions* (1968). Shallow cuts in various configurations in the surface of a dry lake bed, some of these excavations were generated through the operations of chance: One, called *Dissipate,* was based on the configuration of matchsticks dropped and taped down on paper. To be sure, *11 Minute Line* evokes prehistoric as much as contemporary land art—the Serpent Mound, for example, a Native American artifact in Lin's home state of Ohio. But even this combination of ancient and contemporary is likewise familiar: Heizer used the abstracted shapes of a water strider, a catfish, a frog, a turtle, and a snake for his *Effigy Tumuli Mounds* in Ottawa, Illinois, which were constructed as part of a strip mine reclamation project and which clearly evoke Native American precedents along with contemporary geometric sculptures. In her blending of Eastern and Western influences, she also has a precedent—in this case, the landscape art of the Japanese American sculptor Isamu Noguchi,

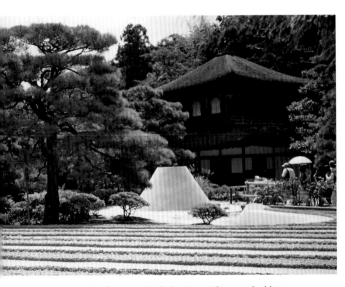

Sand cone at Ginkaku-ji, an Edo-period addition to a Muromachi-era temple garden (ca. 1480) in Kyoto.

who modernized and Westernized the *kare-sansui* garden in his plazas for the Chase Manhattan Bank in New York or—more radically—the Beinecke Library at Yale University, a project with which Lin has direct personal experience.

Indeed, it may be Noguchi whose example Lin most evokes. Noguchi straddled two cultures and was a student of many more; his work was an effort to reconcile the ancient and the modern, the oriental and the occidental, the scientific and the poetic. His project at Yale, completed in 1964, might serve as an example of his approach. It is a sunken court adjacent to the Beinecke Library and made of the same white marble as the building, which was designed by Gordon Bunschaft of Skidmore, Owings, and Merrill. Three sculptural elements are set in a field of pavers: a pyramid, a disk, and a cube perched on one corner. These forms are enigmatic, although the pyramid in Noguchi's work often signified the ancient past and the cube-on-a-point the operations of chance, while the disk is related to others of his sculptures that expressed the shape and energy of the sun. The courtyard pavers, square at either end, become curved and compressed at the center, suggesting the effect of gravity on the space-time continuum described in Einstein's theory of relativity. Noguchi's Yale project deploys the language of Modernist abstraction, but in a setting that evokes the contemplative character of temple gardens; it contains allusions to contemporary scientific theory, but it seems archaic in its use of carved stone and its incorporation of a pyramid. The space is a provocative hybrid; it is formally subtle and meditative in character, qualities Lin has likewise cultivated. Indeed, Lin is one of the few artists since Noguchi to master the combination of a Western, Minimalist-inspired geometry with an Eastern aspiration to create contemplative space.

If Noguchi anticipates Lin in a general sense, he also provides some specific formal precedents. One of Lin's most poetic sculptural forms—the black granite table from which water wells, used in both the *Civil Rights Memorial* and *The Women's Table*—was anticipated in Noguchi's 1974 project for the Supreme Court Building in Tokyo, which features six brimming black granite fountains in a pair of courtyards, one paved in stone, the other in sea pebbles. Noguchi was also adapting the form of the traditional stone water basin, but reversing the principle: Rather than water trickling into the stone, it erupts from the center and spreads across a disk before running down the sides of a massive carved-stone base. Lin used the form to vastly different purposes at the *Civil Rights Memorial* and *The Women's Table*, making it part of specific commemorative contexts underscored by the use of text, whereas Noguchi deployed it to more abstract, even hermetic ends.

Indeed, for all her affinities with other artists, Lin has established a distinct approach for herself. Unlike many other land artists, her spatial imagination is often narrative or historical; it is typically used to emotional ends. The incorporation of text is one apparent narrative device: *Input* uses words to organize spatial experience, as did the *Vietnam Veterans Memorial* and the *Civil Rights Memorial* before it. At the former, the names of the deceased are listed chronologically by date of death beginning at the top right at the intersection of the memorial's two walls and running along the right face until it is swallowed by the ground; the names begin again at the narrow end of the left wall and continue back to the bottom left at the apex. This device provides

Isamu Noguchi, *Sunken Garden for Beinecke Rare Book Library*, 1960–64.

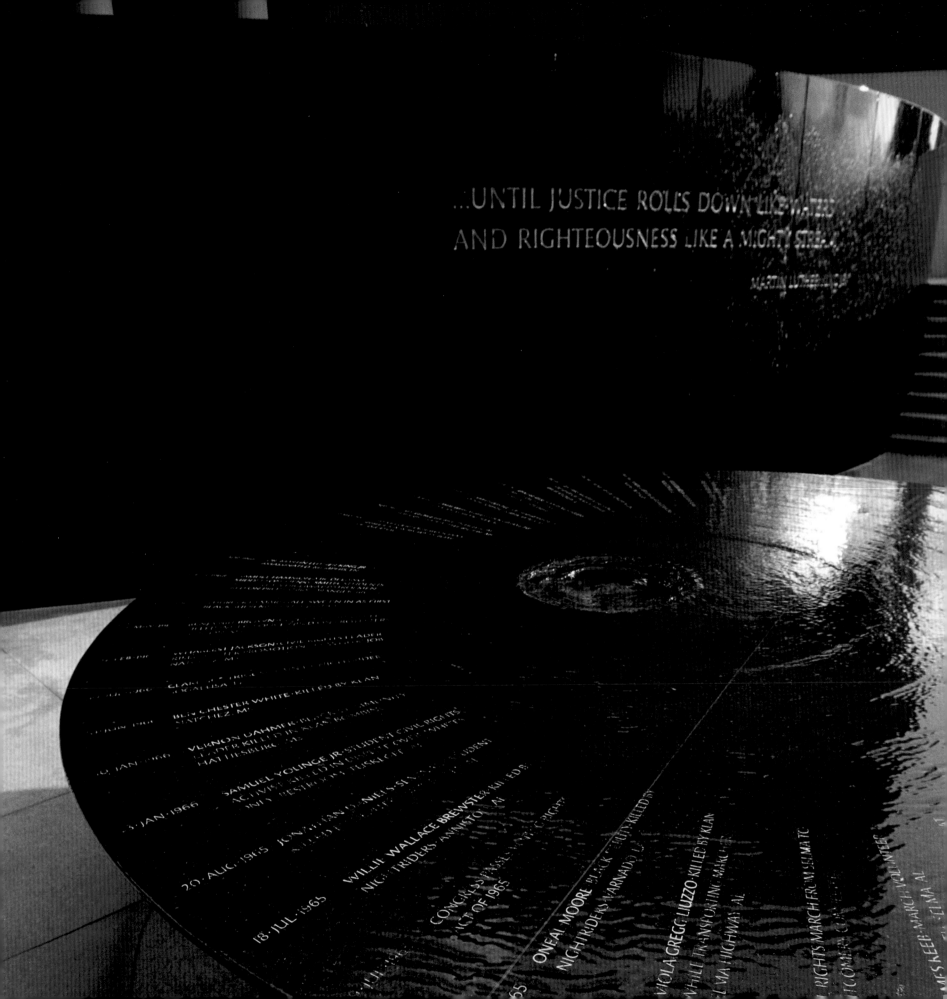

...UNTIL JUSTICE ROLLS DOWN LIKE WATER
AND RIGHTEOUSNESS LIKE A MIGHTY STREAM...

MARTIN LUTHER KING JR.

both spatial and narrative closure for the experience of the memorial. As Lin put it at the time, "thus the war's beginning and end meet; the war is 'complete' . . . yet broken by the earth that bounds the angle's open side and contained by the earth itself."[12] At the *Civil Rights Memorial,* significant events in the struggle to end apartheid in America—beginning with the Supreme Court decision outlawing school segregation in *Brown vs. Board of Education* in 1954 and ending with the assassination of Martin Luther King, Jr., in 1968—are inscribed in a circle along the outer edge of a round table, creating a narrative connection among events. Interspersed between these epochal events are the names of some forty people who lost their lives in the movement. Text can also underscore Lin's emphasis on psychological experience: People seem impelled to touch the names of the deceased at the Vietnam and Civil Rights memorials, creating an emotional identification between viewer and work. Empathy is reinforced by mirroring—you can see your reflection in the polished granite of the Vietnam memorial and in the water that wells up out of the table at the *Civil Rights Memorial* and spreads across its smooth surface.

Input is one of the few instances where Lin has used inscriptions outside the context of a memorial. Here, the text is far more ambiguous, with at least part of it lacking an explicit narrative or spatial flow. It is divided into two sections, with a continuous poem running along the central line of rectangles; arrows on some of the inscriptions tell you where to look for the next one. A more imagistic text is scattered through the rectangles along the edges of the piece, making reference to things like "The stones of a patio/The Hocking overflowing/The sounds of the 17 year locusts/The death of my father." While some of the text relates primarily to the experiences of Lin and her brother, some, Lin insists, "should also resonate with anyone who has spent time in Athens or at the university." Textual ambiguity in Lin's case is purposeful: "I create places in which to think, without trying to dictate what to think." Even in the case of the memorials, she does not present a resolved way of thinking. Instead, she invites contemplation on the realities and the rightness of the social histories she addresses.

Lin's work often demonstrates an affinity for hidden histories: The *Civil Rights Memorial,* for instance, records the deaths not only of the famous but also of the less well known. Lin says she was inspired to recover a history she felt was being lost. She herself had not been taught about the sacrifices made for racial equality in the United States, and few of the victims were familiar to her. The memorial became a way of embodying and representing this history. Similarly, *The Women's Table* at Yale records in a spiraling time line the number of women enrolled at the university: For many years there were none, until thirteen were admitted to the School of Art in 1873; it was not until 1969 that women were admitted to the undergraduate college. For many years before they were officially enrolled, women were permitted to sit in on classes; they were called "silent listeners." "I wanted to make them seen and heard," Lin says simply. Interest in hidden histories is also revealed in her current Confluence Project. A series of proposed memorials to the Lewis and Clark expedition in Oregon became, through her intervention, tributes to the Native American cultures they encountered. The project will also acknowledge environmental transformations: One installation will feature the names of bird species encountered by Lewis and Clark that are now endangered or extinct. The Confluence Project might

be the most rhetorical of her works: "I want people to understand how quickly we can change the world."

Lin is also unlike many land artists in her explicit engagement with science. She is visibly inspired by topography and geology, but her incorporation of scientific content and method is more involved than this. As part of her effort to present the familiar in unfamiliar ways, she uses sophisticated cartography—including spatial modeling and computer mapping—along with satellite photography, sonar, and microscopic images. *The Wave Field,* for instance, evokes ideas of fluid dynamics; it was inspired by an aerial photograph of the ocean surface. Each wave in her field is distinct: slightly higher or lower, wider or longer; these variations in form suggest an idea from complexity science that self-similar phenomena like waves and clouds are never exactly the same. As part of Lin's larger goal to reveal hidden aspects of worlds we think we know, she represents undersea topography, as in *Water Line,* and fabricates sculptures in the configurations of water bodies, including the Caspian, Red, and Black Seas. She wants us to see beneath the surface of things: In the representations of undersea topography, she says, "I'm asking you to think about what's under water." Again, this is partially rhetorical. She sees the distinction between water and land as artificial, allowing us to ignore the destructive impact of pollution, resource exploitation, and climate change on the underwater environment.

As signifiers of distant places, some of Lin's sculptures set up the kind of dialogue between indoor and outdoor landscape created by Robert Smithson in his *Nonsites.* These were collections of sand, rocks, and minerals displayed in variously shaped geometric containers—the "nonsites" —along with maps or aerial photographs of the actual landscapes—the sites—from which the materials were taken. Smithson presented his ideas of site and nonsite in a 1968 essay called "A Sedimentation of the Mind: Earth Projects" and elaborated them the next year in "Dialectic of Site and Nonsite." Smithson conceptualized site as being, among other things, "some place (physical)," while the nonsite was "no place (abstract)."[13] In linguistic terms, nonsite and site relate to each other as signifier and signified. Lin's indoor sculptures might be described as having some of the same kinds of relationships with landscape as Smithson's: Her sculpture of the Caspian Sea, for example, is a signifier of an absent place and an abstraction of somewhere physical. Lin also shares with Smithson a notion of the equivalence of different mediums. Smithson's *Spiral Jetty* exists as an element in an actual landscape, but it also exists as a film, photographs, a drawing, and an essay, all of which have independent identities and equal value as artistic creations. In a like way, Lin's actual works in the landscape are just one aspect of her meditations on the earth, which also include sculptures and drawings that are equally important to her. But again, there are differences between Lin's work and that of Smithson. As she says, "Smithson started inside and worked out; I started outside and worked in."

There remains the question of Lin's relation to contemporary landscape design. Some of her projects approach the conventional language of landscape architecture, such as those in Grand Rapids and Minneapolis. A shorthand description of either would make them sound like familiar functional urban spaces: the one a plaza, the other a corporate atrium. But both feature elements that make the visitor feel off-balance. *Ecliptic,* in Grand Rapids, includes an elliptical

Ecliptic

amphitheater that doubles as a skating rink in the winter; it is surrounded by concentric terracing that slopes—it is slightly above one side of the amphitheater and slightly below the other. The perceptual effect makes the level surface of the rink seem as if it is slightly tilted, giving pedestrians or skaters the illusion of being slightly off-kilter. In Minneapolis, an undulating landscape outside the building continues on the inside, with wooden flooring that simultaneously swells and tilts. Stone benches and tree-planting beds provide a level datum that intensifies a reading of the shifting surface. In both instances, spatial experience is transformed through a subtle orchestration of topography, rendering the ordinary extraordinary and turning landscape into art. As Lin says of *Ecliptic,* "the art part is the perception of the tilt while you are skating—it's a landscape that has art within it." The artistic element is crucial to her: "I don't want to be making functional landscapes." Instead, she insists on perceptual and psychological ambiguity as an antidote to complete functionalism.

Lin's relevance to landscape architecture may lie not so much in her works themselves as in her forms of landscape representation: the many ways she has of excavating the hidden aspects of a site and presenting them to a viewer, which far outpace those of most artists and designers. She never simply draws a landscape; instead, she uses various sculptural and graphic techniques, some computer generated, some executed by hand. She cuts landscapes out of wood or models them in wire. She might sculpt a river system in plaster, registering erosion by scraping out negative space. Or she might use pins in paper, spacing them widely where the river is narrow and fast, more thickly where it pools behind dams or natural obstructions. Perhaps most intriguingly, she makes pastel rubbings of fractured glass that evoke natural processes. They are made by repeatedly striking a sheet of tempered glass with a hammer; the blows release vacuum pressure in glass, essentially causing it to explode. The glass breaks up in patterns of several large fractures and numerous small ones that suggest the fault lines of earthquakes or the cracking of mud as it dries.

To talk about Lin's landscape projects, you have to talk about sculpture, drawing, and landscape architecture, for her work can be all three. Lin has a habit of crossing disciplinary boundaries, but recognizes both the benefits and the limitations of such facility. On the one hand, she is able to work more spontaneously in her sculpture and her landscape projects than in her architecture. In her studio work, she finds the freedom "to think with my hands." This freedom carries over into some of her landscape sculptures. Both *The Wave Field* and *Groundswell* were finished by hand: At the former, she shaped the individual waves with a rake; at the latter, she shaped the piece on-site when the glass arrived. On the other hand, she does not want to be seen as producing hybrids: She wants recognition within particular professional disciplines. "I want my architecture seen by architects, my art by artists." Moreover, working across disciplines presents certain difficulties. "One foot sometimes gets in front of the other," she reports. She'll have a period of great productivity in architecture, while the sculpture or the land art might languish. Then she'll produce several landscape projects in quick succession, as she has recently, but produce less architecture or sculpture. Overall, she reports, "I work slowly. I have cycles of appearing and disappearing." Unlike artists who show regularly or architects who build constantly, Lin

Groundswell

seems to attract notice from time to time in either the art or the architectural press, then retreat for a while from view.

"For my part," wrote Henry David Thoreau, "I feel that with regard to nature I lead a sort of border life, on the confines of a world into which I make occasional and transient forays only, and my patriotism and allegiance to the state into whose territories I seem to retreat are those of a moss-trooper."[14] Thoreau regarded the border with regret: He was neither truly a resident of wild nature nor fully assimilated into society. For Lin, by comparison, the border life is both a challenge and an opportunity. It has provided her with a rich and varied cultural inheritance from which to draw, a fertile ecotone in which to establish roots, where East and West, art and science, public life and private experience overlap and sometimes collide. It has enabled her to set us at the same kinds of thresholds: between cultures, mediums, and disciplines. Paradoxically, her versatility has rendered her highly public and partially invisible, with the full range of her accomplishment somewhat hidden from view. At the same time, the subtlety of her language can obscure her intent—her ambition to shift our perceptual and psychological experiences. For all that, Lin will doubtless continue to go her own way. Her sophistication and versatility have served her well to date, and one can only imagine they will continue to generate work of great consequence.

1. Lin recounts some of this controversy in her book *Boundaries* (New York: Simon & Schuster, 2000) 4:08–4:17.

2. *Boundaries*, 4:08; 0:01–0:08. All unattributed quotations are from conversations with the author, February and March 2006.

3. *Boundaries*, 2:03.

4. *Boundaries*, 4:12.

5. For an analysis of the peripatetic qualities of Serra's work, see especially Yve-Alain Bois, "A Picturesque Stroll Around *Clara Clara*," *October* 29 (1984): 32–62; and Hal Foster, "The Un/making of Sculpture," in *Richard Serra: Sculpture 1985–1998* (Los Angeles: Museum of Contemporary Art, 1998), 13–31.

6. Louis Menand, "The Reluctant Memorialist," *The New Yorker*, July 8, 2002, 59.

7. Foster, 14.

8. Arata Isozaki's exhibition was documented in "Ma: Japanese Time-Space," *The Japan Architect* 262 (1979): 70–79.

9. Teiji Itoh, *Space and Illusion in the Japanese Garden* (New York, Tokyo, and Kyoto: Weatherhill/Tankosha, 1973), 69.

10. *Boundaries*, 5:03.

11. Mark Taylor, "Learning Curves," in *Richard Serra: Torqued Ellipses* (New York: Dia Center for the Arts, 1997), 33–56.

12. Lin, quoted in Ben Forgey, "Model of Simplicity," *The Washington Post*, November 14, 1981, C4.

13. Robert Smithson, "A Sedimentation of the Mind: Earth Projects," in Nancy Holt, ed., *The Writings of Robert Smithson* (New York: New York University Press, 1979), 89–90; "Dialectic of Site and Nonsite" was published in a footnote to his essay "Spiral Jetty," in Holt, *Writings*, 115.

14. Henry David Thoreau, "Walking," in *Henry David Thoreau: The Natural History Essays* (Salt Lake City: Peregrine Smith Books, 1984), 130.

Selected Works, Exhibitions, and Bibliography

Born
Athens, Ohio, 1959

Education
Yale University, School of Architecture
 Master of Architecture, 1986
Yale College, Major in Architecture
 Bachelor of Arts, cum laude, 1981

Sculpture
By Definition, New Jersey City University,
 Jersey City, 2006
Garden of Perception, University of California
 at Irvine, 2005
Flutter, Wilkie D. Ferguson, Jr., Federal
 Courthouse, Miami, 2005
11 Minute Line, Wanås Foundation, Wanås,
 Sweden, 2004
Input, Ohio University, Athens, Ohio, 2004,
 collaboration with Tan Lin
the character of a hill, under glass, American
 Express Financial Advisors, Client Services
 Center, Minneapolis, 2002
Ecliptic, Frey Foundation, Grand Rapids,
 Michigan, 2001
Time Table, Stanford University, Palo Alto,
 California, 2000
Reading a Garden, Cleveland Public Library,
 Ohio, 1998, collaboration with Tan Lin
A Shift in the Stream, Principal Financial
 Headquarters, Des Moines, Iowa, 1997
10 Degrees North, Rockefeller Foundation,
 New York City, 1997
Sounding Stones, GSA/Federal Courthouse,
 New York City, 1996
The Wave Field, FXB Aerospace Building,
 University of Michigan, Ann Arbor, 1995
Eclipsed Time, Long Island Railroad, Pennsyl-
 vania Station, New York City, 1995
Groundswell, Wexner Center for the Arts,
 Columbus, Ohio, 1993
The Women's Table, Yale University, New Haven,
 Connecticut, 1993

Topo, Charlotte Coliseum, North Carolina, 1991,
 with Henry Arnold, Landscape Architect
Civil Rights Memorial, The Southern Poverty
 Law Center, Montgomery, Alabama, 1989
Vietnam Veterans Memorial, Washington, D.C.,
 1982

Architecture
The Box House, private residence, Telluride,
 Colorado, 2005
The Riggio-Lynch Chapel, Children's Defense
 Fund, Clinton, Tennessee, 2004
Greyston Bakery, Greyston Foundation, Yonkers,
 New York, 2003
Sculpture Center, Long Island City, New York,
 2002
Aveda Headquarters, New York City, 2001
Langston Hughes Library, Children's Defense
 Fund, Clinton, Tennessee, 1999
Asian/Pacific/American Studies Department,
 New York University, New York City, 1999

Works in Progress
Confluence Project: Seven-part art installation
 along the Columbia River basin
Art installation, California Academy of Science,
 San Francisco
Art installation, Indianapolis Museum of Art
Art installation, Storm King Art Center,
 Mountainville, New York
Art installations at private residences in Louis-
 ville, Kentucky, and Santa Fe, New Mexico
Environmental Learning Lab, Manhattanville
 College, Harrison, New York
Museum of the Chinese in the Americas,
 New York City

Selected Solo Exhibitions
Maya Lin, Wanås Foundation, Wanås,
 Sweden, 2004
Maya Lin's Designs for East Tennessee,
 Knoxville, 2004
Maya Lin/Finn Juhl, The Danish Museum
 of Decorative Art, Copenhagen, 2003

Between Art and Architecture, Cooper Union
School of Art, New York City, 2000
Maya Lin: Recent Work, Gagosian Gallery,
Los Angeles, 1999
Maya Lin, American Academy in Rome, 1998
Maya Lin: Topologies
SECCA, Winston-Salem, North Carolina, 1998
Cleveland Center for Contemporary Art,
Ohio, 1998
Grey Art Gallery, New York University,
New York City, 1998
Des Moines Art Center, Iowa, 1999
Contemporary Arts Museum, Houston, 1999
Designing Industrial Ecology, Bronx Commu-
nity Paper Company, Municipal Art Society,
New York City, 1997
Public/Private, Wexner Center for the Arts,
Columbus, Ohio, 1993

Selected Group Exhibitions
Summer Sculpture Show, Gagosian Gallery,
Los Angeles, 2006
Group Show, Light Box, Los Angeles, 2006
US Design: 1975–2000
Denver Art Museum, Colorado, 2003
Museum of Arts & Design, New York City,
2003
Memphis Brooks Museum of Art, Tennessee,
2003–2004
Contemporary Arts Museum, Houston,
2003–2004
*Illusions of Eden: Visions of the American
Heartland*
Columbus Museum of Art, Ohio, 2000
Museum of Modern Art, Vienna, Austria, 2000
Ludwig Museum, Budapest, Hungary, 2000
Madison Art Center, Wisconsin, 2001
Washington Pavilion, Sioux Falls,
Washington, 2001
*Nature: Contemporary Art and the Natural
World*, Marywood University, Scranton,
Pennsylvania, 2000

Powder, Aspen Art Museum, Colorado, 1999
The Private Eye in Public Art, New York City,
1997
Extended Minimalism, Max Protetch Gallery,
New York City, 1996

Selected Honors and Awards
National Women's Hall of Fame, inducted 2005
Member of the American Academy of Arts and
Science, 2005
Member of the American Academy of Arts and
Letters, 2005
AIA/COTE Top Ten Green Project for Greyston
Bakery, 2004
Aveda Corporation, Corporate Achievement
Award Winner, Cooper-Hewitt National
Design Museum, 2004
Finn Juhl Prize, 2003
Industrial Designers Society of America Excel-
lence Award for *The Earth Is (Not) Flat*, 1999
American Academy of Arts and Letters,
Award in Architecture, 1996
LVMH, Science pour l'Art Award, 1996
Academy Award Winner, Best Documentary,
Maya Lin: A Strong Clear Vision, 1995,
Frieda Mock, Director
Time Magazine, "Fifty for the Future," 1994
Presidential Design Award, *Vietnam Veterans
Memorial*, 1988
NEA Visual Artists Fellowship, Sculpture, 1988
American Institute of Architects Honor Award,
Vietnam Veterans Memorial, 1984
AIA Henry Bacon Memorial Award, 1984

Selected Bibliography
Amidon, Jane. *Radical Landscapes: Reinvent-
ing Outdoor Space*. New York: Thames &
Hudson, 2001.
Art 21: Art in the 21st Century. New York:
Art 21, Inc., 2001. PBS broadcast, featured
artist segment.
Betsky, Aaron. *Landscrapers*. New York:
Thames & Hudson, 2002.
Campbell, Robert. "Rock, Paper, Vision."
The Boston Globe, November 30, 2000.
Castro, Jan. "One Who Sees Space: A Conver-
sation with Maya Lin." *Sculpture Maga-
zine*, September 2002, 36–43.
Cotter, Holland. "Art in Review." *The New
York Times*, September 11, 1998.
Finklepearl, Tom. "The Anti-Monumental
Work of Maya Lin." *Public Art Review*,
Fall/Winter 1996, 5–9.
Goldberger, Paul. "Maya Lin's Power of the
Serene." *The New York Times*, October 29,
1995.
Hawthorne, Christopher. "Water Works."
Metropolis Magazine, March 2002.
Hawthorne, Christopher. "Somewhere
Between Art and Architecture." Metropolis
Magazine, October 2000.
Heartney, Eleanor. "Distillations of Land-
scape." *Art in America*, September 1998.
Kimmelman, Michael. "Out of Minimalism:
Monuments to Memory." *The New York
Times*, January 13, 2002.
Lin, Maya. *Boundaries*. New York: Simon &
Schuster, 2000.
McGuigan, Cathleen. "An Architect Works on
Paper." *Newsweek*, October 16, 2000, 74.
Menand, Louis. "The Reluctant Memorialist,"
The New Yorker, July 8, 2002, 54–65.
Parfit, Michael. "35 Who Made a Difference:
Maya Lin." *Smithsonian*, November 2005.
Stein, Judith. "Maya Lin—Space and Place."
Art in America, December 1994, 66–71.
Vogel, Carol. "Maya Lin's World of Architec-
ture, Or Is It Art?" *The New York Times*,
May 9, 1994, B1–2.

Checklist of the Exhibition

All works created by Maya Lin (U.S., b. 1959)
All works courtesy of the artist and Gagosian Gallery

Blue Lake Pass
2006
Duraflake particleboard
20 blocks, 3' × 3' each; 5'8" × 17'6" × 22'5" overall

2 x 4 Landscape
2006
Wood
10' × 52'7" × 36'

Water Line
2006
Aluminum tubing and paint
19' × 34'8" × 29'2"

Pin River–Columbia
2006
Straight pins
15' × 16'8"

Caspian Sea (*Bodies of Water* series)
2006
Baltic birch plywood
Sculpture: 10½" × 58½" × 32⅞"
Base: 36½" × 20" × 16"

Red Sea (*Bodies of Water* series)
2006
Baltic birch plywood
Sculpture: 21¼" × 93" × 15¼"
Base: 31" × 30" × 18"

Black Sea (*Bodies of Water* series)
2006
Baltic birch plywood
Sculpture: 18⅜" × 59¾" × 33⅜"
Base: 33¼" × 24" × 16"

Untitled (*Plaster Relief Landscapes*)
2005
Plaster on drywall
24" × 24" × ⅝"

Untitled (*Plaster Relief Landscapes*)
2005
Plaster on drywall
24" × 24" × ⅝"

Atlas Landscape
Rand McNally The New International Atlas, 1981
2006
Altered book
15" × 11⅜" × 1¼" closed
15" × 23¼" × 1⅛" open

Atlas Landscape
Rand McNally Cosmopolitan World Atlas, 1987
2006
Altered book
14¾" × 11¼" × 1⅛" closed
14¾" × 22⅞" × 1" open

Atlas Landscape
The University Atlas, 1984
2006
Altered book
12¼" × 9⅜" × 1⅜" closed
12¼" × 19" × 1" open

Earth Drawing (Wanås)
2004
Cast bronze
2" × 16¾" × 21½"

Earth Drawing (Kentucky)
2005
Cast bronze
2" × 16¾" × 21½"

Earth Drawing (Colorado)
2004
Cast bronze
1½" × 16¾" × 21½"

Wire Landscape
2006
Steel wire
7'2" × 16'9" × 8½"

Fractured Landscape Plate #1
2006
Pastel rubbing
17⅝" × 11"

Fractured Landscape Plate #1
2006
Pastel rubbing
12" × 17⅜"

Fractured Landscape Plate #1
2006
Pastel rubbing
17⅞" × 24¼"

Fractured Landscape Plate #1
2006
Pastel rubbing
18" × 34¼"

Fractured Landscape Plate #1
2006
Pastel rubbing
66¾" × 18"

Fractured Landscape Plate #1
2006
Pastel rubbing
18" × 91"

Henry Art Gallery

Systematic Landscapes is one of the largest and most complex exhibitions organized by the Henry Art Gallery. We are always inspired by the challenge of working with artists who are developing new bodies of work and are delighted to share this work with our audiences. The scale of much contemporary art often requires the space and commitment of an arts institution to realize an artist's vision, and it is my good fortune to work with a staff and board that enthusiastically embrace such museum/artist partnerships.

Maya Lin is one of our country's most influential artists. As her last exhibition, *Topologies,* opened almost eight years ago, this presentation of her most recent installations and sculpture is an important milestone. Lin has been developing ideas for large-scale interior works for a number of years, and the timing was right to work with the Henry to bring these concepts to fruition. I am deeply grateful for her focused time and attention throughout the development of the exhibition and catalogue. *Systematic Landscapes* provides further evidence of her inspiring artistic vision.

Acknowledgments

This exhibition would not have been possible without the support of the Henry Gallery Association and its board of trustees. Eleanor Pollnow, Board Chair, and Sharon Maffei, President, provided energetic and thoughtful leadership in the board's efforts to support this ambitious project. As always, the staff of the Henry stepped forward to take on the creative problem solving that underlies a major exhibition. Chief Curator Elizabeth Brown provided essential advice during the planning of the exhibition, Director of Development Leila Martin and her staff worked vigorously on fundraising, Director of Finance Anne Walsh kept a steady eye on the budget, and Administrator Ethelyn Abellanosa was the glue that held us all together. Communication Manager Betsey Brock applied her high energy and intelligence to the myriad communication needs of the exhibition, aided by the skillful work of Lead Graphic Designer Dean Welshman and Production/Graphic Design Assistant Lynn Fleming.

Maya Lin is ably assisted in her New York studio by Selin Maner, Ahti Westphal, Katie Commodore, Raven Hardison, Sarah Wayland-Smith, and Carl Muehleisen, and the many hours they spent on the details of the installation contributed greatly to the success of the exhibition. Ealan Wingate of the Gagosian Gallery in New York provided insightful advice during the development of the exhibition plan, and we are grateful for the gallery's support of individual works in the show. Richard Manderbach and Ben Black of KrekowJenningsInc. in Seattle provided creative solutions to the many problems relating to the construction of the large installations. David Gallo at Woods Hole Oceanographic Institution advised on *Water Line* and *Blue Lake Pass,* and Gecko Mapping Solutions provided data for *Blue Lake Pass.* Mark Anderson and Dylan Farnum at Walla Walla Foundry worked closely with Maya Lin and the Henry on *Blue Lake Pass* and *Bodies of Water.* I am very grateful for the involvement of Jane Jacobsen, Betsey Henning and Brian Boram of the Confluence Project for their many efforts on behalf of this exhibition and the materials they provided for the gallery dedicated to the Confluence Project.

The Henry has a superb exhibition staff and they rose to this challenge with aplomb. Exhibitions Manager Paul Cabarga provided much appreciated oversight of the logistics and budget, Registrar Sallie-Jo Wall played a central role in the exhibition planning and scheduling of the

prep crews, and Tamara Moats, Curator of Education, worked closely on the interpretive elements, programs, and publications. I particularly want to thank Head Preparator and Exhibition Designer Jim Rittimann and Supervising Preparator Dan Gurney, as well as Preparators Eric Adami and Laura Reiter, for their outstanding work on the construction of the installations. Their leadership combined with the hard work of the other members of the prep crew created four major new works of art during a four-month period.

Many thanks are due to John Beardsley and Lawrence Weschler for the texts provided for this catalogue. Their thoughtful contributions give readers significant insight into Maya Lin's artistic vision. I am also grateful to Carolyn Vaughan for her invaluable editorial guidance and to Curatorial Assistant Karen Nystrom for her meticulous attention to rights and reproductions issues. This beautiful catalogue is the result of the combined efforts of many at Marquand Books. Ed Marquand oversaw planning and design, and John Hubbard provided an elegant design. Early on Patricia Fidler, Publisher, Art and Architecture, Yale University Press, expressed interest in the catalogue, and I am very pleased that Yale is copublishing this volume with the Henry Art Gallery.

The complete list of sponsors of the exhibition and catalogue are listed at the front of the book. However, I want to call special attention to the Paul G. Allen Family Foundation for their ongoing generosity and to the extraordinary support and vision of William and Ruth True, Sharon and Greg Maffei, Cathy and Michael Casteel, Susan and Furman Moseley, Victoria N. Reed, and Eleanor and Charles F. Pollnow.

Finally, I would like to thank my wife, Colleen Chartier, for contributing the photography of the installation works for the catalogue and for her patient support throughout.

Richard Andrews
Director, Henry Art Gallery
Exhibition Curator

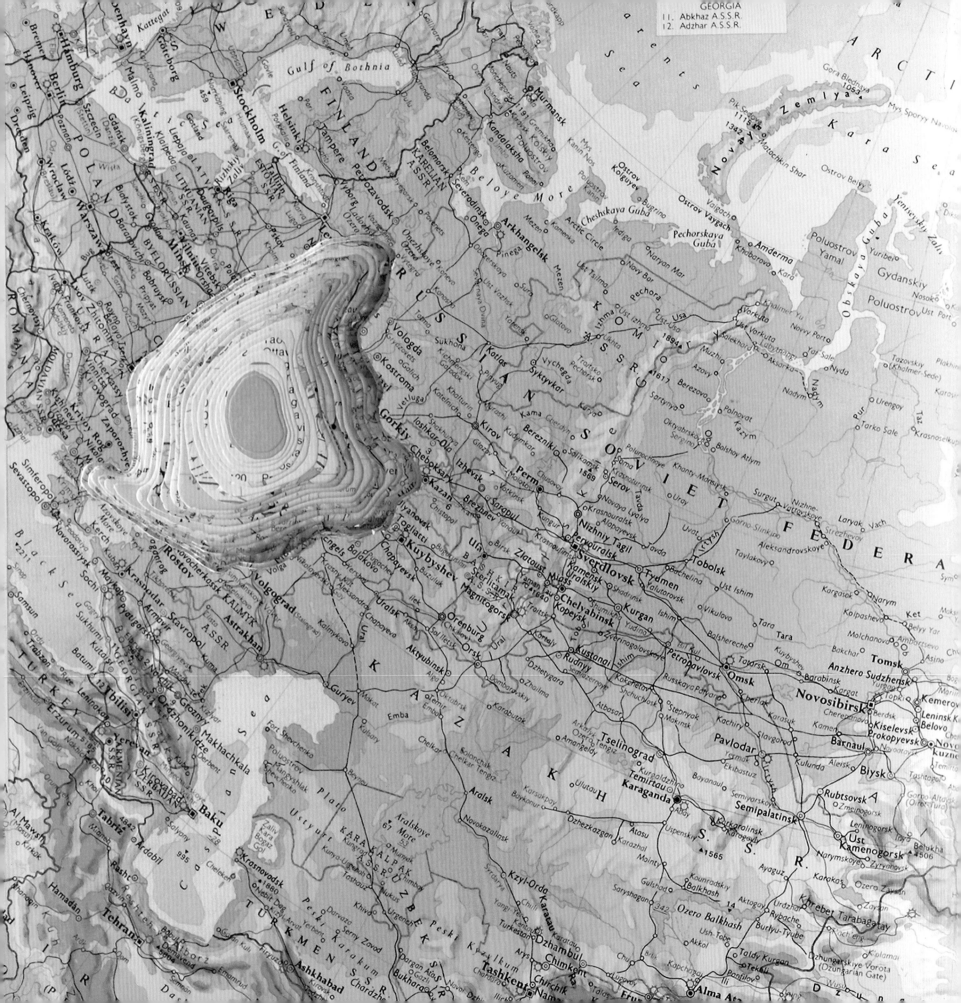